COMMON HEROES

COMMON HEROES

Facing a life threatening illness

BY ERIC BLAU, M.D.

NEWSAGE PRESS

Dedication

To the many people who opened their homes and their lives to my inquiries and served as my guides to the experiences of dying.

Acknowledgements

I wish to thank all of you who advised and encouraged me in the creation of this book. Special thanks are due to Scott Browning, M.D., for his unswerving belief in the value of my work. To Scott and his colleagues, Tom Campbell, M.D. and Barbara House, R.N., for putting me in touch with many of the people I photographed. I would also like to acknowledge my energetic editor and publisher at NewSage Press, Maureen R. Michelson, for her vision and for believing in my work. And to my wife Julie, whose love and support nurtured me through the years of making this book.

Address inquiries to: NewSage Press, P.O. Box 41029, Pasadena, CA 91114.

First Edition 1989

Cover and book design by Rich Newman

Printed in Singapore by Eurasia Press

Library of Congress Catalog Card Number 89-061200

ISBN 0-939165-12-0 Softcover

I am convinced that my life belongs to the whole community; and as long as I live, it is my privilege to do for it whatever I can, for the harder I work the more I live. I rejoice in life for its own sake. Life is no brief candle for me. It is a sort of splendid torch which I got hold of for a moment, and I want to make it burn as brightly as possible before turning it over to future generations.

George Bernard Shaw

The People There is no more dramatic characterization of the human condition than its termination. A certainty amidst uncertainties, so stark an event as death should hardly seem so difficult to reconcile. We may study death in the abstract but we learn of death and its personal meaning through the random sequence of friends and family dying in the myriad of ways people die. Each death has its own unsettling features, and oftentimes, regrets. The swift and unexpected deaths leave us with an incomprehensible emptiness and the wish to be able to retrace past moments and unfulfilled resolutions. The recognizably fated deaths present less mystifying but more frustrating discomforts—how to cope with the need to embrace and to let go, how to live out our relationships in the shadow of their inevitable end.

In this remarkable book lies the opportunity to encounter the phenomenon of dying in the dimension of our choice. We see and hear from a disparate group of people who share a common experience—they may be dying sometime in the not too distant future. Death emerges from the necessary abstraction it remains for most of us to become a dominant context in their lives. Physical decline and medical reinforcement mark their course and pace them through a process that seems reassuringly unique for each individual. Their awarenesses are shared with us in a most candid, verbal and understated photo-journalistic presentation.

They speak to us nonjudgmentally about our cultural and personal ambivalence toward the dying. They share their own concerns, as well as empathy for those to be left behind. They give us a momentary vision of themselves, frequently looking surprisingly healthy, in the ordinary settings where life is sometimes casually, and often emotionally, lived out. It is this perspective that gives us so much latitude as we engage this work. The intensely emotional aspects of dying are all here— physical and emotional pain, bitterness, isolation, fear of abandoning and being abandoned—but we are not assaulted by them. We can let our encounter focus and refocus.

This, to me, is the essence of *Common Heroes*: so complete is the portrayal of the process with candid dialogue and casual, but dynamic photographs. We can accept the charges of ignorance, fear and concern for our pain and their own anguished concern for the unwitnessable future of their children. Above all, we can heed their warning not to run from them. We can accept with them the fears and complexities of this process as they affirm our own suspicions that this can be a bewildering and at times, paradoxically peaceful experience.

Much can be taken from the experiences of these people. They have, as have we all, spent much of their lives in the conscious and unconscious cultivation of uniqueness. This process does not end as we begin to die. We see herein that in the process of letting go, our individualization may become more, rather than less, complete. In this sense there is great hope. We may well see ourselves and our loved ones more clearly in future encounters because we have been allowed to see these people. Encountering and re-encountering this book produces a new image and insight each time. *Common Heroes* offers the opportunity to learn, and more importantly, to give as much as possible in our future experiences with the dying, and ultimately with our own deaths.

Dennis R. Leahy, M.D.

The Photographs

Words and photographs have equal capacities for telling the truth. Each has as much veracity or mendacity as the person using them. Two of photography's primary characteristics are its ability to record a subject virtually instantaneously, and to depict its subjects accurately. The camera is the ultimate recording device of surfaces. With the addition of words, the reader can go deeper than simple surfaces, and that is the power of *Common Heroes*. Dr. Eric Blau's work with individuals facing a terminal illness requires equal doses of words and pictures to provide "wholeness" in his subjects.

To photograph individuals with a prognosis of a terminal illness, and capture the normalcy of their lives where the illness plays no particularly visible part in the photograph, is a curious approach for a physician. Yet that is half of Dr. Blau's process. The other half entails long interviews with his subjects about their illnesses and how this affects their lives. The photographs are a living response to the people; a response that endows them with life and wholeness. It is an exercise in visually healing them. The words offer insight into an experience that affects people of all ages, races and levels of wisdom. Dr. Blau makes their vitality paramount and permanent; this is not a catalog of disorders and medical jargon. While the photographs deal with surfaces and appearances, for the people portrayed in *Common Heroes*, as is the case with most of us, the problems and concerns are below the surface. Words become the more penetrating element reaching below the surface.

The people in this book seem so ordinary and they look like people we might know—maybe even ourselves. The portraits record not only the subject but also the feelings of the photographer and the necessary social interaction between the two. The patients' apparent health can create confusion for the viewer because it is more difficult to separate them from our preconceived ideas of what we consider "healthy" or "ill." Our fears about pain and death make these people hard to relate to. We are uncomfortable around people that remind us of our own mortality. The built-in voyeurism of photography allows us to scrutinize these people without the discomfort of personal confrontation. We search these portraits for some signs of illness or impending death, but only occasionally is any evidence visible. In many ways, the patients in this book look typical and not particularly brave, but they are. So is Dr. Blau. He faces them in a nourishing, life-giving mode and in turn, they have opened themselves up to cooperating. Their openness and insights help us to deal with the common occurrence of dying.

We rarely appreciate every day as though it was our last. We often compromise our appreciation of the moment because we expect to live much longer. The very act of the people in this book participating in the creative process of this book indicates a will to grow and nourish their lives, and in turn, our lives. By their sharing and unearthing their feelings, they are indeed more fully alive than those of us not willing to face mortality.

Science has aided us in our ability to both prolong life and fight death, and therefore, to know when we have a disease that may be terminal. *Common Heroes* shows us that illness can happen to anyone, people like ourselves, and that if necessary, we may be able to fight it, should we elect to. As the people in this book teach us, a terminal illness offers us the opportunity to gain insights about ourselves and to learn from it. Ironically, this experience of learning may give some of us our fullest and most meaningful years.

Arthur Ollman Executive Director,
Museum of Photographic Arts, San Diego

Introduction

To be terminally ill in America often means dying in isolation. Our society has unwittingly transformed the final stage of life into a rite of passage frequently removed from daily experiences. When one is faced with a life-threatening disease and is labelled "terminally ill," one soon learns of these changes: the confrontation with frailty and mortality, the changes in attitude that health care workers assume when they can no longer cure a patient, and the sometimes lonely interactions these people experience with close friends and family.

I began interviewing and photographing people with terminal illnesses in late 1984. As a physician as well as a photographer, I have cared for many such people and observed the difficulties they, their families and the medical profession have had in forthrightly confronting their diseases. I naively thought I was comfortable with the subject of dying and would be just the person to impart my knowledge. Armed with this hubris, I began my project.

I decided I wanted to talk to people who had already been told by their physicians or personally knew that they had a terminal illness—people who knew they were dying. However, I found myself asking the question, "What defines dying? How do you define terminal? Is a patient with Lou Gehrig's disease who has years of life left considered terminal? What about a person with cancer who is in remission?" In the end, I chose people with illnesses that would shorten their expected lifespan; people who were confronting death.

At first it was difficult to find physicians willing to refer people to me for this project. In some cases, they were "protecting" their patients from some obscure damage I might do by talking to them about their life experiences. In others, the doctors themselves expressed discomfort in broaching the subject with their patients. Some doctors could not be bothered. Slowly, I found people to talk to and my own education began.

I was surprised to discover how nervous I was when I started to ask these people for permission to photograph them, especially when I acknowledged to them that they were seriously ill and that dying was a real possibility. After all, how else was I to explain what I was doing? In the beginning, I used euphemisms in an attempt to soften my inquiries, but I think I was the only one who needed the tempering. I remember my first interview. It was a cool autumn day in Southern California and as I walked up to the front door, tape recorder and camera gear in hand, my heart was pounding, my hands were ice cold and my forehead was covered with perspiration. When my hostess answered the door, she immediately asked if I was all right. It took me about 30 minutes to settle down. Those first interviews were difficult. I would repeatedly change the subject when I became uneasy, usually when the people I talked with became emotional. With time I grew more comfortable and, I believe, became a better interviewer.

My photographs also changed as I understood more about what I wanted to do. I started by attempting to make emotional photographs that conveyed illness; people in bed appearing ill. I wanted the viewer to experience their infirmity. At first, I was seeing these people as individuals transformed by their illness. However, early into the project I stopped viewing these people as different from me; they were working, going to school, involved in political activities, getting married, caring for their children, and taking vacations. They were doing all the activities one attributes to healthy people. I realized that illness was not the essence of their lives. What became clear is that these people were living under a handicap partly created by their illnesses and partly by the dysfunctional responses of their families, friends and health care workers. My new focus was to exhibit and protect their humanity, the common bonds that they shared with me, and ultimately with the viewer. I wanted to create images of people within which we can see ourselves.

Repeatedly, the people I photographed talked of how hard it was to get important people in their lives to talk openly about issues of illness and dying. Often, I got the feeling that my one visit was the only time when they had the opportunity to talk frankly about these concerns. When I arrived, usually another family member was present and it often felt like this additional person was there as a "chaperone" to protect the person I was interviewing. After the conversation began, the relative often left the room. However, more than a few times, our conversation was interrupted by a voice from elsewhere in the house shouting, "You never told me you felt like that!" Unfortunately, a lack of communication with family members was a complaint voiced all too often. It seems that the very people who would be most comforting to the ill often needlessly create more anxiety by their own inability to communicate.

The people I photographed and interviewed taught me much about living and dying. I feel fortunate for the opportunity to have entered their homes and been made privy to their thoughts. Hopefully, their stories will also help others to learn more about this time of life.

Eric Blau

COMMON
HEROES

*A*ll my friends were shocked, just as much as I was, when they found out I had a lymphoma. I wasn't sure if I was going to die or live or what was going to happen. I didn't know if I was going to be cured or not. You hear of people with cancer and you hear of them dying and that's what you think of. When friends and relatives found out, they all started paying attention, calling and sending letters. But I didn't associate with my friends as much because what I used to do with them is go surfing and stuff. When I got sick I couldn't surf and that kind of put me out of the group; but my friends would still ask me how things were going.

I didn't know what the chemotherapy was going to be like. At first, I just kept getting reports of people being real sick and I didn't hear of many kids on chemotherapy. But I did hear of a lot of old people who spent weekends in the hospital every treatment and they just got sick at home and felt nauseated. Once I started chemotherapy, I only felt sick the first couple of treatments. At first, the treatments were worse than I thought they might be because the chemo hit me hard the first treatment or two. After that, it wasn't as bad as I thought it would be. It's a different kind of feeling sick. You don't feel pain in one place, but most of the time you just don't feel good. My whole body doesn't feel up to things and I feel a different kind of nausea. I guess it's like morning sickness with pregnant women, having to eat when you don't want to. That's what my mom tells me. I get a lot of nausea and I wasn't expecting that.

The toughest thing about my illness is that my looks and everything changed for awhile. That's a tough part to deal with. My treatments are one week apart and I feel sick, but not real sick. Each day I feel like I'm getting better and right when I start feeling good I have to go in for another treatment, which is a pain because I start feeling good and then I have to go in and feel bad again. I just can't wait for this to get over.

My advice to other people who get cancer is, "Don't think that death's right around the corner," because with all the stuff they've got nowadays, they should be optimistic. After I started the chemotherapy, I thought, "There's no way I want to die. There's lots of things I want to do." When you have that optimism, that helps your body, so you're not down in your head and your body doesn't feel that way either. Just be real optimistic.

David Coons

*D*avid and I are very close, but we've been closer since he's had the cancer. The ways he feels, I feel. When he's up, I'm up. When he's motivated, I'm motivated. I lost 14 pounds when he lost 11 pounds. It's been like a roller coaster. Like I said, when he's nauseated I feel down and on his good days, I feel great. I want him to feel good all the time and I feel so helpless.

Karen Coons

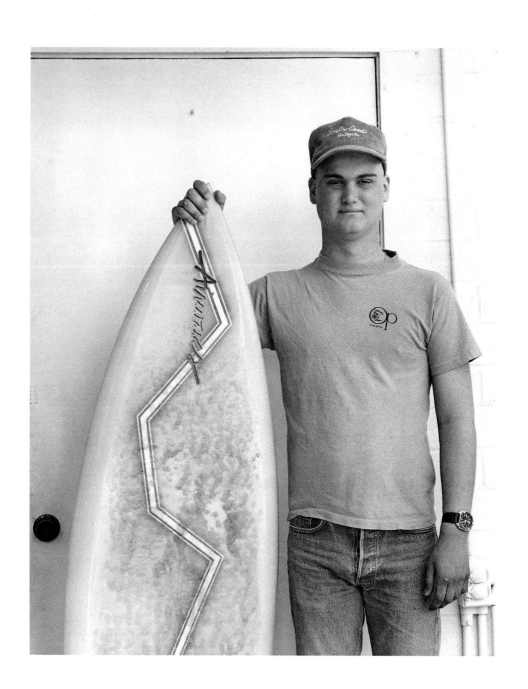

*T*hree years ago I first found out that I was ill. I was shocked and devastated. I was shocked mainly because I was considered low risk for breast cancer and I had just had a baby. She wasn't a year old yet when I discovered the lump while nursing. I thought it might be a clogged milk duct and when I saw the doctor, he wasn't concerned about it. Of course, it ended up being something different and that was really surprising.

Hearing the words that I had cancer was devastating. I had an appointment with the surgeon and he set up a time for a biopsy. Then he changed his mind and thought that we would do a needle biopsy and still schedule me for a regular biopsy. He did the needle biopsy and I didn't think all that much about it. When I went to have the other biopsy done, I had to wait for an hour to see the doctor and I was nervous already. But I was thinking about just getting the biopsy done and not getting any results from the needle biopsy because he had told me that sometimes the results are not conclusive. My husband was with me that day, and when the doctor finally called me into his office, and before either one of us could sit down he said, "I have bad news for you, you have cancer." It was like somebody had hit me in the stomach, all the air was taken out of me. I really didn't appreciate the way it was told to me. I imagine it's hard for any doctor to tell a patient that news, but I think it could have been handled better. He could have led up to it a little better by saying, "We have the results from the needle biopsy and this is what it is."

The doctor immediately started talking about having a mastectomy done. It was just too overwhelming. We weren't given any time to adjust to what we had just heard, much less start making plans immediately. If the doctor would have acknowledged that we could be going through some pretty heavy emotions right then and said, "I'll give you a minute just to collect yourself," that would have been really nice. But he didn't do that. It was difficult to concentrate on what he was saying because I was reeling from the news. I was trying to adjust to the news and then listen to what he was saying. It didn't work out very well.

I ended up getting a second opinion and when I first talked with this surgeon he looked at the lab results and all the things that I had done to be sure that I did in fact have cancer. Then he just looked at me and asked, "Are you scared?" I said, "I'm petrified." He put his hands on either side of my face and said, "We're going to make it better." That was all I wanted to hear. I knew he couldn't take away my cancer, but I wanted to know I wasn't alone—that someone was going to try to help me.

The idea of having a mastectomy is really hard for me. For anyone, having your body altered would be hard to adjust to. But my feelings were that I felt I was doing something constructive and positive to take care of the disease. I was hoping that the mastectomy would be the end of it. It wasn't. They found cancer in the lymph nodes and so that was another blow. I was scared and knew that I'd have to go through chemotherapy. I'd heard some pretty bad things about chemotherapy and I just wasn't sure what the future held. Since I have three children, I was concerned about what would happen to them and leaving them with my husband. I consider my children a great responsibility and one I had hoped to see through until they were adults.

My husband was great. I think I'm really lucky in that respect. He was very supportive. He was also devastated. We've been married 17 years and it's interesting to see how something like this affects him. In one respect I was flattered and taken aback by the depth of his emotions

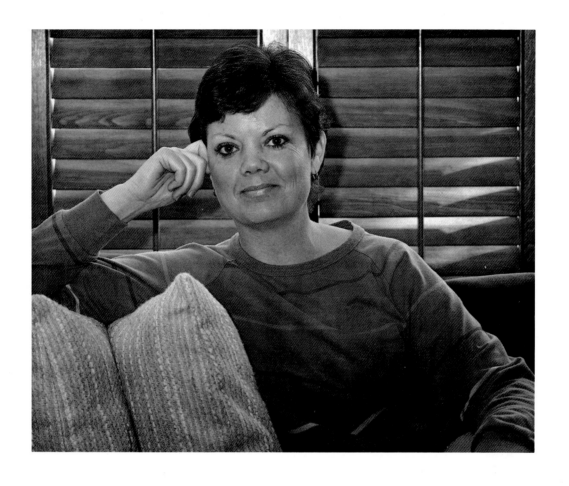

about this. Then it scared me because I realized, I guess for the first time, what I meant to him. I knew what he meant to me, but to see that you mean so much to someone else is kind of scary. After the mastectomy, my husband never made me feel that he loved me any less. In fact, I felt like he loved me more. He was very attentive and concerned about what I was going through and my feelings.

My children have known from the beginning what was happening and they are very upset about it. At this point, they've kind of blocked what's happening with it. I've had a recurrence so that brought it all back and upset people again. But I feel that it's real important to be honest with them and to let them know what's happening. I don't like what's happening, but I can't help it. I'll do what I can to stay with them, but I can't predict what the outcome is going to be at this point.

Especially at first, I think everyone thought that this cancer was a death sentence. You know, almost immediate. Everybody was real upset. I think my mother was more concerned about my self-image after the surgery because she wanted me to go through the breast reconstruction. I had gotten to a point where it wasn't that important to me, but it was to my mother. She kept pushing me toward breast reconstruction. I found it interesting that she was so involved with that. I think it is very upsetting to my mother that I have cancer because I'm her youngest child. She kept telling me she knew that I would be fine, that everything was going to be all right. At first, it didn't bother me when she would say that—-I wanted to hear it. I wanted somebody, anybody, to tell me that everything was going to be fine because I wanted to believe it myself. Now when she says it to me, I just kind of let it roll off my back because I know it's not that easy.

My family doesn't talk to me about my illness very much, particularly at this point. They may ask me how I'm feeling, but they don't want any in-depth idea of what's going on. At one point, it was difficult with my husband while I was going through chemotherapy and I had days when I was all right and days when I was really down. He would just say to me when I expressed a fear, "It's not going to be that way. Let's not talk about it." I would have to tell him, "I realize it may be difficult for you, but I need to talk with you about my illness and what we need to do and what my wishes are." I think my husband tried to get to the point where he wanted to shut it out, but I wouldn't let him.

One of the more disappointing experiences for me was with a friend. We had met at work and we'd had babies six months apart, so we kept up our friendship. We both quit work and stayed home with the babies. When I went through all this with my illness, she definitely didn't want to talk about any of it. She didn't want to know what I was going through and she made it clear she didn't want to hear about any of the chemotherapy. What surprises me about this is that her husband is a doctor and she's the one that got me to see another doctor for a second opinion. I think my illness made her feel uncomfortable and she wanted to think of me as the way I've always been. My sense is that it really bothered her when I went through the chemotherapy and she saw the physical changes in me. It seemed to really bother her. She wanted things to be alright and they weren't. It was difficult for her to handle, so we have just drifted apart.

When my boss found out that I'd had a recurrence of the cancer, he told his assistant and she immediately started making arrangements for someone else to start doing some of my work. This really upset me that people were already starting to paint me out of the picture. It was

particularly upsetting since I work in a medical setting at a hospital; you expect them to be a little more understanding. It's ended up that I'm still doing all the work that I did before and things are going along reasonably well, but that was upsetting. When I got a new boss, it was different. I had to go to the doctor a couple of times to figure out what was happening and my new boss asked what was going on and how I was doing. He has been very supportive, asking me how I'm feeling. He seems interested, as if he cares.

When I was in the hospital, I found it really interesting that a lot of the nurses would come in at night and talk to me and ask how I was feeling. It ended up being because of their own fears of breast cancer, and I was about their age. One nurse said she'd found a lump and was scared to go to the doctor. It really surprised me to hear a nurse say that. But after I thought about it, I decided, "Well, it's not so surprising, she's a human being first. She's going to be afraid of what the results could be and just because she's a nurse doesn't take that fear away."

I feel very strongly that it's not so much the idea of death that bothers me, it's dying and what I may have to go through to die. I worry that I would be a burden on my husband and my children especially, and I'm afraid of them seeing me in a deteriorated state. That really bothers me and I don't know how to get around it except that I try to tell myself that I'm not at that point now, so not to worry about it. My husband doesn't worry about it, he says he'll do what he has to do and that he loves me. That's nice, but still I don't want my husband and my children to see me that way. I think that even if they feel they can live through it and want to be there for me, I'm afraid of what I'll see in their eyes.

I appreciate things more now and try to tell people I love them more often instead of just thinking that they're going to know that. I don't take things for granted so much. As far as planning wonderful vacations or doing things that I've always wanted to do, I still have those desires, but I don't have the financial means anymore now than I did before. The important thing is my family and having them settled.

I think everybody knows that at one time they're going to die, but you don't really face up to it and you always think it's going to be further down the road. To be faced with something like this is really a hard thing and there are so many other factors involved that I believe being honest is the most important thing. I was really struggling to get to a point where I felt maybe there was some hope and also accepting the disease, but still living what life I have left and without going through it crying everyday and feeling that life isn't worth living. I want to live the time I have left to the fullest. When I first saw my oncologist, the doctor who is treating me now, I walked away from his office very depressed after the first visit. He wouldn't give my any false hope. He was very realistic about it and after awhile I came to appreciate that. I don't want to feel that somebody is keeping something from me because then I can do much more damage to myself. Your own mind can create more things than are there. I want doctors to be honest with me and tell me what to expect, what my chances are, and then I can deal with it.

Cecilia Succetti

*T*hree years ago I first found out I had cancer. Up until that time I had never been ill. I was a light heavyweight boxer and I used to run on weekends and play tennis a lot. When I found out I had cancer, I was really devastated. I just saw everything before me lost—all the places I wanted to go, all the things I wanted to do with my wife and around the house. I just didn't want to work or do anything because I didn't have any energy and I didn't see any future once I got ill. I said, "How could this happen to me?" because I take all kinds of multiple vitamins and I did most of the things a person does to stay healthy. I had never been sick and I really couldn't believe it.

Then I started to think, "Well, I'll throw off this illness." I started reading and doing everything I could to take my mind off the illness, but it was really too much for me. I was devastated, it felt like I'd lost my best friend, like someone in my family had died. I couldn't get rid of the hurt feeling inside. I kept thinking of some of the things I had heard people say about cancer. If a person had cancer, everybody would stay away from him. I felt that I didn't want people to know that I had cancer because I kept thinking it was something else and I just couldn't believe I had it. I didn't want to tell anybody that I had cancer. I got through the radiation therapy and that made me feel a little better; I felt bold about saying I had cancer because I had some sort of control over my thoughts. I think it's important to gain control because no matter what the doctor has said or what it looks like, you can fight it. On my low days I can stay up, but I have to keep renewing my sense of control.

If I could change my life, I would have done more to create better understanding around the conflict that is going on between the races and why people are poor. I also wouldn't let myself be used—I wouldn't let people in the South do things to me that I didn't want because I was afraid. In the time that I lived I would have been more vocal and I would have tried to break down some of the racial barriers. In growing up, I did what most of the blacks did in order to survive—they let themselves be used. I'd be more aggressive and more vocal.

James Stone

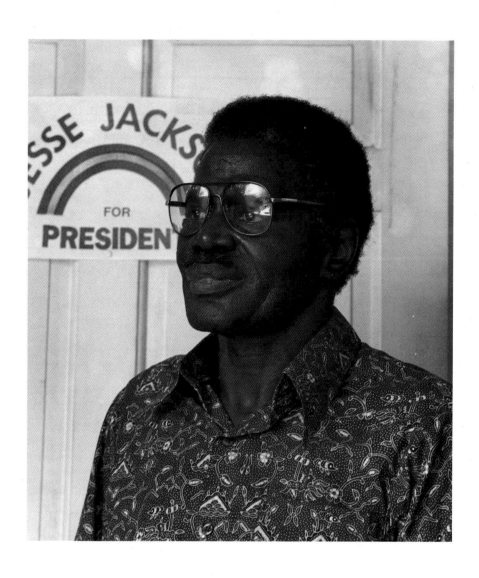

When I was told I had prostate cancer I didn't feel all that bad. I wasn't set back on my heels or anything like that. I'd been through a lot in my life and I always came out the other end. My response was, "Well, here's another one." The family doctor just got really uptight when he told me about the cancer and started yelling in a high-pitched voice like it was my fault. He called me in and said, "The x-rays show prostate cancer." He was very excited and I didn't respond like he thought I might. I was rather even in my response and I think he wanted more. Maybe he was covering up his own feelings of blame for not having detected it earlier or something like that.

In dealing with a serious illness, the idea of humor has helped me a lot. It might help if doctors could recommend humor and that individuals not take themselves so seriously. I've become a humor nut. I look for humor everywhere I go. What I want from my friends is to tell me a lot of really great jokes. I've made it a big thing to laugh in the hope that it will build my immunity. As a psychologist I'm well aware of the healing qualities of good feelings and humor and even simple involvement. I don't think that a person expressing sympathy towards another person necessarily helps him. I need other things than sympathy. I need humor and more than anything else, I need intelligence from people; that's what I crave. Who knows, I may just get over the disease. That's what I want. I think sympathy or empathy, if it's sincere, is good, but not for me. Sympathy is lacking in interesting content—for me, it falls flat.

My wife and I argue a lot about who's right and who's wrong. A lot of the arguing she does with me is, I'm sure, due to the fact that she herself feels anxious and depressed over this thing. That frustration has to be converted to anger. My relationship with one of my daughters has gotten worse. Maybe she feels anger. She has more anger with me than before, and what the motives are, I don't know. I can guess that one of the reasons is that I am sort of "center stage" rather than her. Another being that she would like to show caring, but she doesn't know how, and all she can show is anger. My other daughter is very busy with her life. She's rather soft and caring and asks me how I feel and all of those things. At the same time, she's busy with herself, which is good. They're both active people with deep involvements, which is what they were taught to do.

What I think about dying is rather simple. I have a feeling that I'll just become extinct and to become extinct means to lose the precious stimulation, meaning an involvement. I think this is the real reason people are afraid of death. They're afraid of not having stimulation, not having an involvement or awareness. So, what I'm doing, is packing in as much of it as I can before I die. Since I don't know what dying is about, and I'm not about to accept some rabbi's idea or some guy in India or whatever, I'm simply saying I don't know what it is. When it happens, maybe I'll find out, but I have to leave that for last. I'll have to deal with it then. Right now, I'm going to deal with being alive as much as I can.

Irving Kaplan

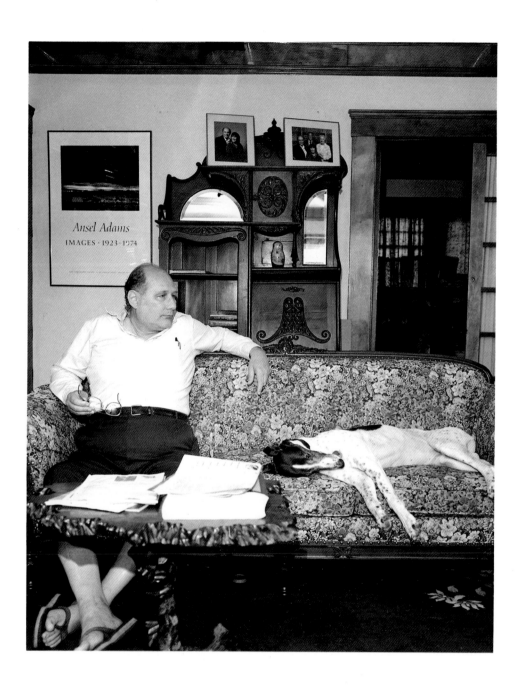

*N*o one ever told me I was ill, I knew I was ill. Late in 1981 I knew something was terribly wrong, so I told the doctors what I had and it was their business to confirm it. Since I'm a medical research chairman, it didn't take too long for me to figure out what was wrong with the classic presentation of my symptoms. I have ALS (amyotrophic lateral sclerosis or Lou Gehrig's disease).

I didn't take the news personally, I just took it fairly fatalistically. I have a lifetime of working with terminally ill people, so I was inclined to live very hedonistically from the beginning. I have always lived as though there's no tomorrow and sure enough, there's no tomorrow. So it was actually a very appropriate disease for me to get.

I have to manipulate people now. When you can't do anything, you end up being a supreme manipulator and I don't like doing that, but I have to. I now look at people as functions. For instance, there's "the girl who takes me out on Fridays," but it's not "Marilyn" anymore. That's a bad feeling, it affects how I deal with people. I always feel that I don't want to be so nice to them that they think I'm just being nice because I want them to do something for me. It does put a hamper on my ability to express my feelings to someone. Now that I have to ask for things to be done for me, I'm always gauging what kind of mood the person is in. Every little wish I might have, I have to think over and ask myself, "What is that person's burden index today? Can he take it?"

I've been very depressed a few times, mostly about lack of help and the inability to do something. There's a depression that accompanies each major loss of a function; when I can't walk anymore, when I can't stand up anymore, when I can't floss my teeth anymore. I'm also depressed sometimes about the lack of physical contact, particularly with my husband. He has not come near me physically for more than a year. He's just not a very physical person to begin with and I always had to do the chasing. It's not just sex, I'm not having anything with my husband anymore. Even if he would just crawl in bed with me and put his arm around me, that would be nice. I understand about sex, it just became too painful for him watching me deteriorate. You can deny the deterioration if the person is always sitting up in a wheelchair, but if you're actually touching the body, it's emotionally painful to realize that your partner can't move a leg anymore. I know what is happening to me, so it's not like every two weeks I have some revelation like I can't move my legs; but for my husband, it might be the first time he realizes this.

We now have a person living with us and her helping me has taken a lot of the anxiety away. I used to have a lot of anxiety about whether I would make it off the toilet in the morning. . . things like that. My life revolves around really stupid things, like whether or not I will once again get my underpants back up. What a banal way to live.

I would like to die at some point, sooner than I would otherwise die. If I'm lucky, I'll choke on a croissant. If I'm not lucky, I'll be in the hospice on a lot of Valium and just go under.

Linda Zarins

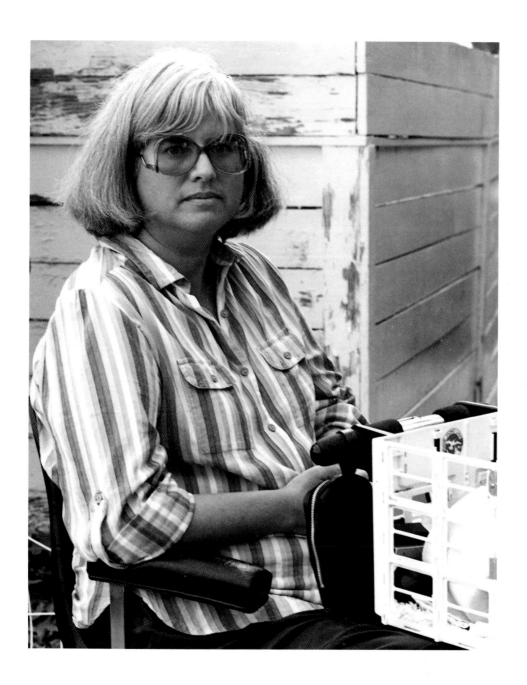

*A*bout 11 years ago I was first told I had a type of leukemia. I knew so little about it then that it was frightening when I first found out. The doctor explained to me that it was chronic, it wasn't acute, and that I could go in and out of remission for years and still live with it, which I have done.

I didn't have any pain, but I was just going on and off medication all the time. The last year and a half have been very bad for me. I didn't go into remission and that's when the real bad bladder infection started. I was in the hospital three times the first year. I can't do what I used to when I was a very active person, like go to exercise class every morning. I don't have the ability to do it anymore, and for me, the worst part is that I have to sit way too much. I feel like I'm on my last leg, probably, and that at anytime I can get an infection and God will take me. That's the way the doctor explained it to me, too.

Well, I'm not afraid of dying. I'm a Christian and I just try to live the best I can every day—to make the best out of every day and not worry about what's going to happen tomorrow. My children don't like to talk about death. It doesn't bother me. They say, ''You're gonna be okay, Mom. You'll be fine.'' If I say,''I don't believe so,'' they say, ''Don't talk that way. Don't give up.'' I like to face reality and I want them to face reality, but they don't want to. You know, we all have a certain day on which we will have to go. It isn't the fact that I am going to die that frightens me, it's just leaving my loved ones that's hard.

Ann Miller

I think my wife's illness has brought us closer together because I've had to pay more attention to her and help her along. It's been quite an ordeal, but still, it's brought us closer together. We don't make any long range plans these days, but just plan on doing things day by day.

I don't think of my wife's illness as terminal in the sense that she's got three months, two months, or anything like that. I figure this is long range. You know, of course, I'm terminal too in the sense that we all die.

Earl Miller

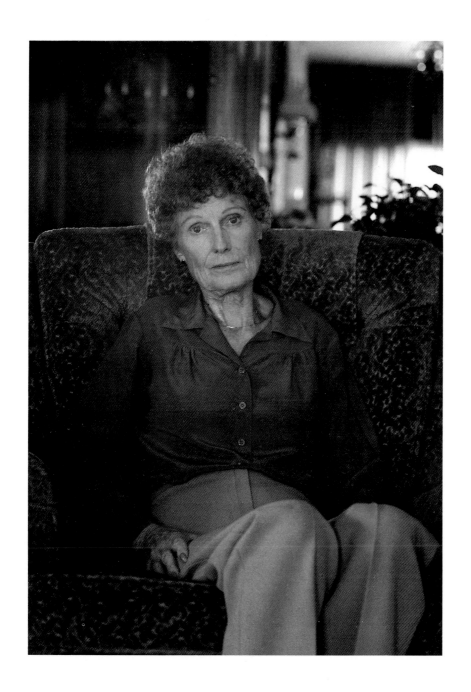

*M*y doctor said that as of now, everything seems to be going well, but I'm still a little bit frightened. He said he might be able to control my cancer, but I sometimes say that I don't care about my cancer anymore. I just want to get well with my hands and legs so I can walk and do something for myself. Sometimes I still need help in doing things for myself and I don't want to bother anybody, even if they are my family. I want to be on my own and I don't want to be a burden to anyone.

I'd like to go back to work, any kind of work, but my doctor tells me I can't because of my condition. When I'm working I forget all my worries and all my problems because I'm just paying attention to whatever I'm doing.

At first, I just wanted to die. Now, I want to see my child grow up. That's what's keeping me alive. I just want to see my son grow up. I don't want him to go to an orphanage.

Candelaria Cruz

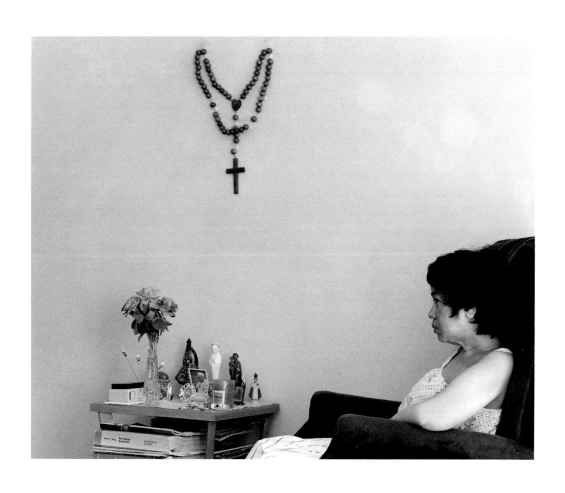

*F*or the first month on chemotherapy I was bedridden. I couldn't eat, I couldn't do anything. I was constantly throwing up and having diarrhea. Finally, the doctors got the right balance; enough therapy and enough of the stuff that wouldn't make me throw up. There are times now when I am really sick. I'll get a shot on a Tuesday and I can't keep anything in my stomach from Tuesday until maybe Friday. Whatever I eat, I'll throw it up. Whatever I drink, I'll throw it up. Sometimes I wonder, "Is it worth staying alive to go through all of this?" Then comes Friday and I'll get to feeling a little better. And Saturday, I'm okay and I'll go out to lunch with some friends. Sunday I'm okay. Monday, I'm getting depressed because I know that on Tuesday I have to start all over again.

My wife goes to work in the morning and the kids are in school, so that leaves me at home all alone. Either I read or I watch television. I can't get up and do the housework, and I can't get out in the yard anymore. That's all been curtailed. So I am either reading or watching TV. After awhile I get bored, I have nobody to talk to and I become angry. I get angry when my wife and kids come home. I've been sitting there all alone, watching TV all day, or reading, throwing up, or whatever I'm doing, and that's where the hostility comes out in me sometimes. I know I shouldn't be hostile and I know that they haven't done anything to really upset me, but I'm already upset. I take it out on them, but they understand. At least my wife and son understand.

I don't think I could tell anybody what it's like to be ill. Everybody goes through a different experience. What I have and the way I live is totally different from anybody else. I don't think any two people are alike when it comes to life. I can't tell anybody anything about how to live or how to go through this illness. If you're a man of God, then you're going to get into God. If you're a man of science, then you'll go with science. But as far as telling somebody how to live their life after contracting cancer or any kind of disease, I can't do it.

I don't want friends and family to look at me like I'm sick. This friend of mine knows I'm sick, but he never treats me differently than the way he treated me prior to my illness. We go out, we argue, we fight, drink or do whatever. He'll cuss me out and call me an old sickie, but it's all in jest. I don't want anybody looking at me any differently than the person I've always been. If you start giving me a lot of sympathy and pity, then I'm going to start expecting it. When you start doing things like that then you indulge yourself and that's no way to live.

Clifford Daniel

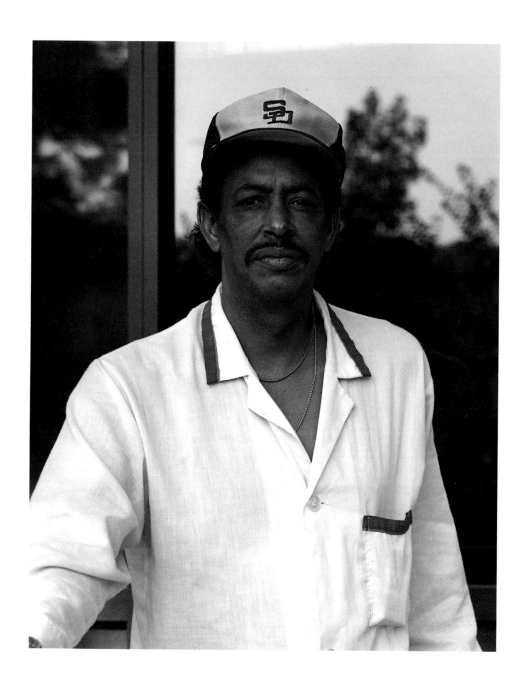

*B*efore I was diagnosed, I already knew that I was ill. I had spent three months not knowing what was going on with me. The doctor said, "We're looking for pulmonary pneumocystis and if you have that we can treat it." When I had my bronchoscopy and they found I had it, my first reaction was, "Thank God." But a little while later I discovered that he was saying, "You're going to die soon." I didn't understand that I had AIDS, but I suspected it. I insisted that the doctor test for AIDS, but he said, "You don't have to be tested, there are certain things that show up that tell us you have AIDS."

When the doctor told me, he was very matter-of-fact, which impressed me because I was aware that he was giving me a death sentence. He wanted to put me in the hospital that very minute. Nobody said, "Gee, I'm really sorry." It was just, this is the fact. This helped me a lot because the attitude of the doctor and nurses was that this is just a normal course of events for an AIDS patient. So, I haven't over reacted yet. . . but I think that I'm going to.

During the three months before I got the diagnosis, I began feeling sick, but I put off treatment. I was doing a play and the day after the play ended, I started seeking treatment. By that time I had lost about 15 pounds and my lungs were fatigued. It was really starting to get difficult for me to move around. I called the hospital, told them my symptoms and they gave me an appointment for two weeks later. But after five days I called the hospital back and said, "I can't wait," because I was deteriorating rapidly. The first doctor I saw was a family practitioner who took some initial tests. A week later, I called and his nurse said, "Your results are negative, so you're alright." I assumed—silly me—that meant that I was normal, that I didn't have AIDS. I automatically thought they had tested me for AIDS since I told them I was a high-risk person, but they hadn't.

After the nurse gave me the results, I was sitting there still unable to breathe and unable to walk. I said, "Well, I still have this problem. I need another appointment with the doctor." It was almost three weeks later that I got my appointment. My impression was that they were treating laboratory tests, looking at numbers, rather than looking at me. By the time I went back to the doctor, some of the symptoms showed up in the tests. As I was leaving, the doctor put his hand on my shoulder in a very sympathetic way, which was new, so I knew at that point something real serious was going on. I suspected that I had AIDS, but I had suspected it for about two years.

In a way, it was good to know what I had, having just gone through several months of not knowing. There was relief. After that, I became depressed and I didn't know it. One doctor talked with me for more than an hour one night in the hospital, and he was the one who pointed out to me that I was depressed. I told him, "You know, I feel like I forget things. Mid-sentence I might forget what I'm saying. Is this affecting my brain?" The doctor said, "No, it's

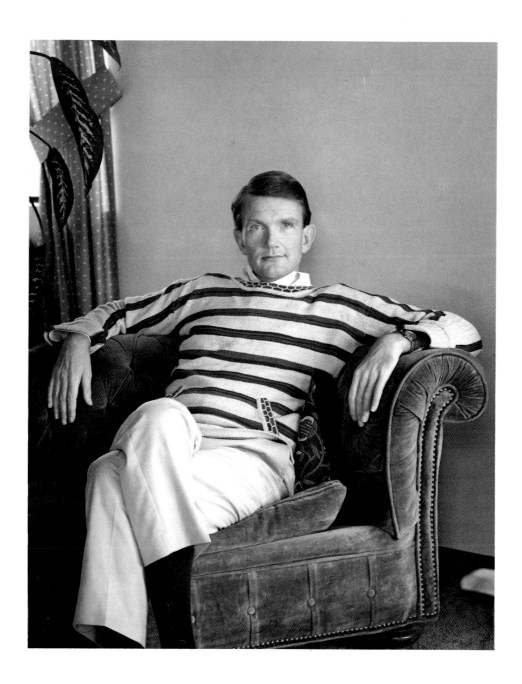

the first sign of depression." He gave me some pills to remove anxiety. It's awfully hard for a doctor to say, "We want to make you stress free, but you're going to die." This is something that I have to work out.

I'm getting tremendous support to work this out. About six months ago I moved to San Diego from Los Angeles where I had lived for 20 years. That move could have been very frightening, but I have some good friends living here. My best friend lives here and I've known her for about 14 years. I don't have any gay friends, but the reaction from my friends has been so positive that it has changed my life. They come over almost daily and check in with me. One friend did my laundry and cleaned my house. Yesterday, my best friend came over and vacuumed because she knew I was going to be photographed.

My friends, as well as the doctors I deal with, have made physical contact with me. I soon became aware that what they were translating to me was, "You're not a leper, so I'm going to touch you." If I dwell on it, I feel a little guilty because I feel like I'm putting them through something they shouldn't have to deal with. I don't feel comfortable knowing that my friends are going to watch me deteriorate and I'm sure they have absolutely no idea what to expect—I didn't. I went to the AIDS Project to find out where I was going with this disease, but I had put it off for two weeks because I was afraid. I told the support group at the AIDS center, "On the one hand, it's helping me very much to be here, but it's also validating every fear that I have." I'm going to continue attending the group because there's a comraderie that I didn't expect, and already I care for those people.

My mother and my brother both know that I am gay, however, I've only told my brother that I have AIDS. I wanted to tell my mom—my father died in 1944—because I've told her everything that's ever happened in my life, but I haven't told her about this. She's old, she doesn't need to know that her son is probably going to pass on before her. There's always the chance that I won't; if I don't, she didn't know. Eventually, when it gets more obvious that I'm sick, I probably will have no problem telling my mom, but right now I'm well. However, my brother knows and I have talked to him about the disease and about dying. My brother is two years older than me and he asks very logical and analytical questions. I talk to him a lot and when he's in town on business, we get together. For my last birthday, he told me he wanted to buy me a plant and asked what kind I wanted. I said, "Send me a hanging plant." My brother asked, "A fern?" I said, "Oh, no, send me a wreath." It took him aback, but I needed to share that kind of humor with him. It's almost like I want people to understand that I'm not going through this great tragedy. I'm going through something, but I don't look at it as tragic. I've become more alive in the last three weeks than I have been in three years.

When I talk to friends or to my brother about dying, they don't say, "Let's hear about it," but they do know I need to talk about it. They don't shy away from the subject, but I do know it's a strange topic for them. There is a little holding of the breath that I sense. What I fear most is how I'm going to die. Intellectually, I look at going through the process as an adventure. I had a roommate in college who had a heart attack and died. When I heard about it, the first thing that occurred to me was, "You lucky son-of-a-gun, you're going to see things before I do." I don't know where that thought came from because I'm not that self-destructive. I've read Elisabeth Kubler-Ross' writings on death and dying and I know that death is a part of a continuation, it's

not an end. So, a part of me is okay with that, but shedding my physical body scares me a lot. I know it's all going to happen and I don't want to spend a whole lot of time thinking about those things. Every once in awhile, three times now, I've just started to cry. I know that's natural—it's probably my subconscious thinking about death.

I've discovered in the height of my illness that I can sit down and write plays and comedies. I have never sat down and finished anything like that and now I've got my third play completed and there are other things that I want to do, including writing about what's happening to me and the different feelings I'm going through. I'm just an ordinary person who has this thing happening to him and people need to know about it. I want to do something that's rather uplifting and inspirational.

I believe that before I was born, I chose all of this. So, it's hard for me to think that on the other side I made a wrong choice. I have a friend who has been fighting cancer for 17 years and it sounds as if she's very near to passing over. She is the mother of one of my former students and I remember one time when we were talking about my belief that we choose things that happen to us. She got very irate and said, ''I did not choose cancer.'' At the time, I thought I was flippant and stupid for making that statement. But now that I'm in the same situation, I still believe it.

About two years ago, I stopped having any kind of intimate sexual contact with other people. It coincided with my joining Alcoholics Anonymous and not drinking anymore. I've never really had long term relationships, but if I knew that I had given somebody the disease, I don't know how I would deal with it. I believe there are paybacks in other ways in other lifetimes, so I'm not one of these angry people who wants to go out and strike back at the world.

My advice to friends and family of someone who has a serious illness is to allow them to talk about it. Do not give way to hysteria, that doesn't help. That kind of response is for the other person and their own grief, and they can do that somewhere else. The two most important things for me are just to have someone to talk to and have someone with me.

Robert Cyr

*O*ne thing that needs to be said is that the family has a right to know. To keep this from the family is a disservice. My husband and I went back to spend Christmas with our son and our only grandchild, who is 12 years old. We decided we wouldn't tell them until the holiday was over. Wayne hadn't started any treatment and he was not too well. Our granddaughter said, "What's the matter with grandpa, doesn't he like me? Is he mad at me?" When she went to the movies, we told her parents. After returning home from our visit, they decided to tell their daughter. She was more upset by the fact that she thought grandpa was mad at her because he wasn't talking to her and kidding around with her. After she found out that he was ill and that it could be terminal, she was less upset. She was able to handle it better knowing that the reason he was acting strangely was not because he was mad at her but because he was ill. As it goes along, our granddaughter is growing and accepting this, and when the time comes, she will be prepared.

Evelyn Lee

*A*pproximately one year and eleven days ago, I was told by a doctor that I had from four months to sixteen months to live because of lung cancer. Well, that doctor made what I would deem to be a random philosophical or psychological analysis of the situation without having it substantiated in any way medically speaking. He just told me I was going to die and that's it. He was quite direct and forceful in his diagnosis. I think that doctor would have been more professional and more accurate if he had qualified his diagnosis and not made it so final and definite.

This doctor's first concern seemed to be with me getting my house in order with God and I told the man, "Doctor, with all due respect, I'm not here for religious therapy, I'm here for medical advice. I can take care of my religious needs and wants, but I need help for my physical report." He didn't know whether I was an atheist or a Jew or a Catholic; he didn't know a thing about who I am. He didn't know if I was capable enough to absorb this kind of information and to accept it. Would I fly off the handle? Was I emotionally stable enough to cope with it? Could I have been a mental case? There are all kinds of people and from my point of view as an accountant, it behooves me not to make any accusations about financial affairs unless I know what the hell I'm talking about.

My wife and I set out, pardon the vulgarity, to make a liar out of this first doctor. We got associated with another doctor who is a fantastic man and a fantastic oncologist. He said, "I think we can put this cancer in remission." I said, "Doctor, you call the shots and I'll be the best damn patient you ever had." So the wife and I made up our minds that we were going to make that first doctor eat his words. I felt real good after I got a second opinion. I wasn't in any mood to go out celebrating, I'll concede that, but this second doctor told me that we could put this cancer in remission. I'm going to join forces with him and help fight it.

The hardest part about being ill is having to depend on my bride of 40 years so much. Twenty-four hours a day. I mean, there's a little timer that goes off at three in the morning and if I don't hear it, she does. She says, "You've got to take your medicine," and "What do you want to eat?" It doesn't make any difference what I want to eat, she'll fix it because that's what I want.

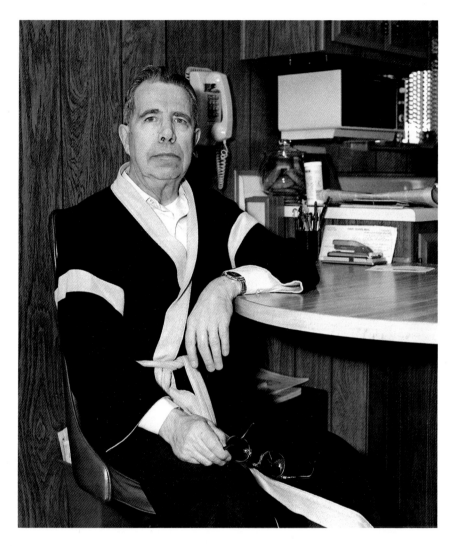

That bothers me. I miss not being able to work and not being able to be a husband. I haven't been able to be intimate with my wife for five or six weeks and that's not normal. So I'm trying to get back to some degree of normalcy. Things are a little bit better now physically as far as strength is concerned. But having been relatively sound of mind and at least body for my six decades, all of a sudden to find myself in a position that I can't walk across the room without becoming overly tired has had a traumatic effect on me psychologically.

I'm optimistic about my illness. There's optimism personified in my wife and you can't live with a woman like that and not be optimistic. In spite of the way that I feel right now, we're talking about terminal illness. My stepfather died the day before his 62nd birthday. He didn't qualify for social security. Well, I guess I'm just greedy enough that I'm going to hang around and I'm going to draw me some social security checks. If that means I've got to hang around for a year to do it, then by God, that's what I'm going to do.

Wayne Lee

*N*aturally, I was greatly impressed by the news that I had leukemia. But bad news is not new to me. I've had bad news in the past, although not quite as severe as someone telling me that I have a form of cancer. I didn't completely understand what that meant when I first found out. I knew that if I wanted to try to recover at all, I was going to have to go through chemotherapy. When I was a well person I had friends who were going through chemotherapy and I knew what it meant to them and the suffering they endured as a result of the chemicals they ingested in the hope of life. I did not want to go through that so I asked my doctor how long I had to decide. He looked at his watch and said, "I'll give you three minutes and I'll be standing outside the door." Fortunately, my husband was in the room with me at the time that we got the diagnosis. So we had a three-minute discussion and both decided that what we had together was worth fighting for.

The hardest change in my life since becoming ill and taking chemotherapy has been the vomiting, without a doubt. If they could do something to take care of the nausea, I'd be one happy person. When I'm in the midst of a rough chemo cycle with one of the more evil chemicals, I wish I were dead. Anything would be better than just praying at the porcelain idol.

There were points in the course of my treatment when I was taking it one hour at a time. I would tell myself, " I'll take it from noon to one o'clock and if I can make that, then I can read four more pages of Agatha Christie." She's one of the things that made my time in the hospital bearable. Because you suffer so many tactile deprivations in the hospital, intellectual stimulation really helped a lot. And of course, visitors meant a great deal. I would say to anyone who has a friend with cancer, "If you really want to do something for him or her, visit them and talk about something other than the illness, please."

After my diagnosis, I began to reassess what I felt was important in my life, given that I might have a limited, or let's just say, truncated life. I decided that I was doing too many things that I did not enjoy doing, simply out of some sense of obligation. I promised myself that I would not talk to any relatives I really didn't like. I hated my job at the time and I promised myself that if I ever got well enough, I would leave it and find a job that was more fulfilling. I've since accomplished getting better, I've found a new job and I'm having a great time.

Carol Redding

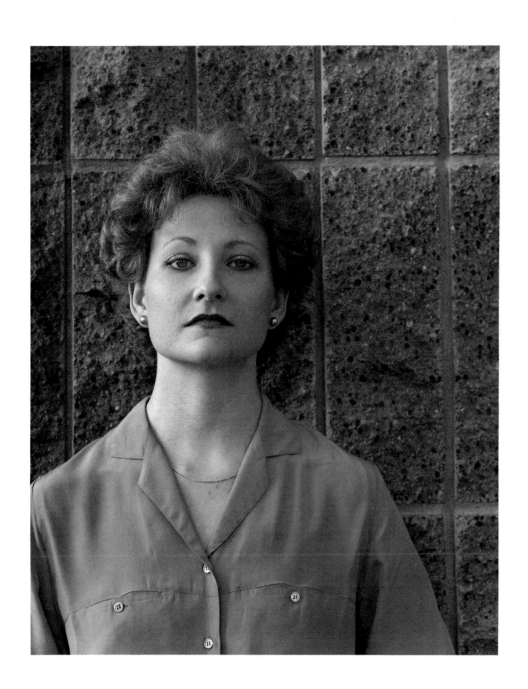

*J*ust knowing that I have an inoperable cancer and that it may be terminal is enough of a shock. But then, to also undergo these little pains here and there, some of which are probably magnified because I'm aware of it now, concerns me. However, my biggest concern is for my family and children, not for myself personally. I've always felt that I've led a pretty active and complete life. I have an extreme amount of faith and I'm a religious person, so learning I had cancer wasn't terrifying to me. I still have a lot of faith that we might be able to reverse the bowel cancer, both medically and faith-wise, but I'm aware that it could be terminal.

I am extremely concerned about being a burden. In discussing death, I'm not afraid of death. I've discussed it with my associates at work and with other people who are close to me long before I knew I had a serious illness, and it was always my feeling that death didn't scare me. What scared me was not being able to get around and having somebody be responsible for the everyday things of feeding me and taking me to the bathroom. I've never wanted that to happen. I've even told my physicians that I don't want my life prolonged just for the sake of prolonging it. I would rather live as much of a normal life as possible and if it came to the point that there wasn't really anything left to do, except to extend my life by respirators or some other heroic efforts, then I didn't want that to happen.

With my wife, I sometimes wonder if I burden her with all the little details that go on with me; how I feel at a particular moment, or that it hurts or that I'm hurting from my ulcer or that I have a special pain or that a few hairs are coming out now or whatever. She's one person to whom I can talk. She's told me on several occasions that she wants to know what's going on and sometimes I wonder whether I'm being too informative or not informative enough—or maybe I should keep some of these things to myself because it might not be anything.

We've been very open with our children from the time that we first knew I was ill. We sat down with them and basically explained what was going on. We told them to ask us any questions they wanted, but that we may not know all the answers. And then as soon as we could, without getting on the telephone, we asked the other children who are not living with us, to come see us and then we explained it to them in detail. By detail, I mean just explaining that there is a serious illness that could be terminal in whatever time frame it takes, but also holding out the hope that there is a possibility I might not die from this, and there may be a cure eventually. The reactions of our children to my illness varies, depending on each one's personality.

I have one close friend who is very religious and has a great deal of faith that praying will also cure you. I personally believe this may happen. But one thing I cautioned him about: "I want you to understand that you believe that I can healed, but if for some reason it's fatal to me, does that make me less of a believer? It's great to expect a miracle but to demand it of somebody can make them feel like they may not have the necessary faith to be healed."

DuWayne Berreth

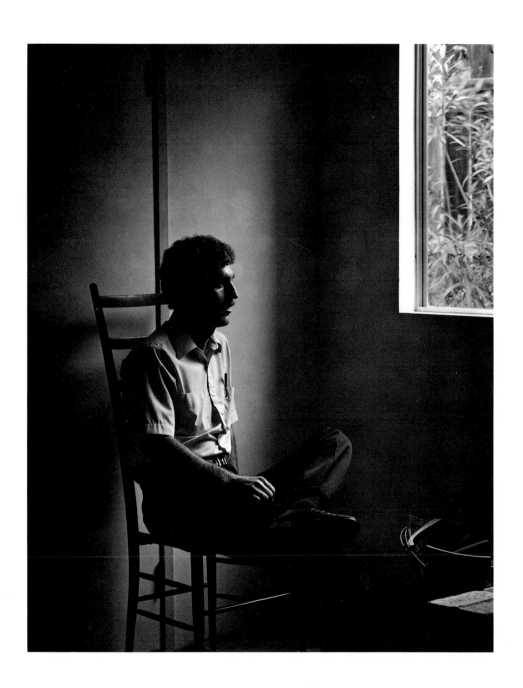

I am not afraid to die. I am more concerned about being an invalid and having to be dependent on someone else 100 percent. Euthanasia is something I believe in because I would not want to be tied down to life support systems. The hardest part of my illness is that my wife and I may not be able to carry out some of the plans we put together. We have plans for a secure retirement, but I may not last long enough to provide for that.

When I first found out I had cancer, I had a morning appointment with my doctor. I went from the doctor's office to work and I had trouble concentrating on what I was suppose to be doing. I wondered what this meant and what I was going to do. After work, I went to the school of medicine library and looked up some information on my disease. I didn't talk to my wife about it until I got home; I had to prepare myself first. When I told her, we both sat and cried together. Everytime we started to talk about it, we got emotional. It was about a month before we could just talk about my illness and keep the emotions in the background. Now, that the initial shock has worn off, I don't have a problem talking about it.

I would like to get more feedback from my doctor. In some cases I ask for it and in some cases I don't, but I'd like the doctor to volunteer more information about my illness. I get the feeling that the doctor has only a small amount of time for me during my visits and that he has to do a certain amount of things, and then he is gone. I'd like a progress report with more details— how is my interaction with this disease progressing and what is the path I'm going down.

Gene Johnson

*M*y husband is the nicest, most gentle man. . .I always felt that if there was a God, this cancer would not have happened.

Son-ja Johnson

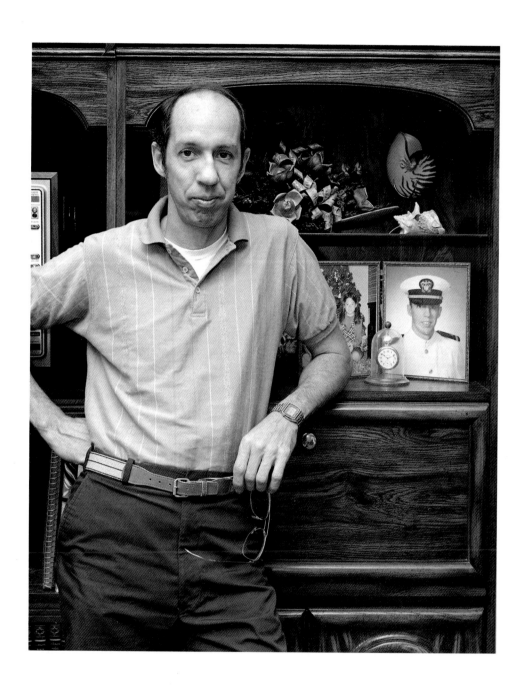

*K*eep in mind that for the first years of my illness, my biggest problem was not the physical disease, but a psychiatric one. I truly went off the deep end. I was extremely psychotic and crazy. I felt a total sense of helplessness that things happen and I have no control. I had a real feeling of despondency. Such hopelessness. I was very suicidal. Our whole lives were disrupted while I spent six months to eight months at a time in locked psychiatric wards. Nothing you could ever experience is as painful as psychic distress. Nothing I can go through can ever be as bad as the hell that I went through all those years. Everybody stands a risk of having too much to cope with and running out of coping mechanisms. That happened to me.

Usually, in those times at two in the morning, when I'm alone with my thoughts, sometimes I feel very tired of this world. But these are brief episodes and I realize that when dawn comes and I'm up for the day, I somehow can't relate to the image of dying. There's also a part of me that's really at peace with the idea of dying. I recognize that at some point I will die and I think in a way that I'm more accepting than most people who acknowledge intellectually that we're all going to die, but somehow it won't be me. I've reached points where I did not want to live; I felt that I was 300 years old and I had lived more than I ever wanted to and I was tired. I was so tired I just wanted to literally go to sleep and never wake up.

I think it's real hard to tell people anything about a long term illness and coping with it. There's no way that I can tell someone what is the right way or the wrong way. However, I would encourage people to find a way to talk about their feelings. In other words, find a safe way just to explore your own feelings, which may not necessarily be with a spouse. It might be with a therapist or someone who can let you talk; someone who can reassure you that feelings are normal and they're not dangerous. The only danger you get into is if you don't express the feelings. It's a real adventure to have a physical disability and a progressive disease. I don't necessarily mean that in a positive way. It's simply as if you're driving down the road of life and all of a sudden you've gone off on a route that you never anticipated. You take it and it's truly an adventure.

Nancy Sawhney

I have lived my life the best I can. I have no fears of death. The only thing that concerns me is a lingering death that would be painful and that would cause my family a lot of pain watching me.

Wendell O'Dell

A year ago, I first found out that I had leukemia. I just couldn't believe it was happening to me because out of our whole family, I thought I was the healthiest one. When I first found out about it, I thought, "Oh my God, I've got three weeks to live." I put a time limit on my illness and everything else. But the three weeks passed and I was still here and then I thought, "Oh well, that wasn't too bad."

In the beginning I didn't want to talk to anybody because I figured I had to deal with it myself first. In my case, where my parents live so far away, I thought the best thing was for my husband and I to deal with it first before we had to take on my parents too. I needed space to handle the news and work it out in my own way before my parents knew, because then I would also have to handle their problems about it. I didn't want my parents to mother me and I didn't want to have to mother them. If I'm sick, my parents want me to stay in bed or lay down and let somebody else do all the work for me. I don't want that.

It was hard for me to tell my parents because they live in Missouri and I had to tell them over the phone. I talked to them on a Saturday morning at seven o'clock and I cried for a long time. I thought I was going to be dehydrated from all the crying that I was doing. I called them again that afternoon because I figured maybe then they'd at least grasp it a little more. I knew it was hard on my parents because they're so far away. Once my husband and I got ourselves together and we were okay, then I told my parents it was okay to visit me. When they got here and saw that I looked okay, they were all right with the situation.

As soon as a couple of people in the apartment complex where I live and work found out that I had leukemia, the news spread like wildfire. I manage the apartment complex so all the tenants know me and they visit the clubhouse and play cards. It was hard for me because I would walk in the room and I could clear that clubhouse faster than anybody I know. Everybody wanted to avoid me for the first couple of weeks. Then they got to the point where they'd say hi, go through the nice, cordial things and then leave. After awhile they got curious and they'd ask how I was, but say nothing more. Then they started asking what was going on and how things were going. Now, it doesn't seem to bother anybody. I kind of understand what they were going through because I didn't know much about cancer until I did a paper on it for a college class. In my paper I mentioned that I thought a lot of people had what I call "cancerphobia." They're just scared to death of cancer, scared they're going to get it and die immediately, so they don't want to really talk about it. But my experience has been that once people see that you're doing okay and you're normal, then they start getting a little bit curious about it.

Most of my really close friends are back in Chicago, so I really haven't seen any of them. There's one that I write to, but she didn't write back for a long time. She used to send

Christmas cards and then this last Christmas she didn't send a card and I wondered why I hadn't heard from her in such a long time. I kept writing and writing, and finally, she wrote back and said, "Tanya, I don't know what to say to you." I wrote back and told her that she was treating me no different than anybody else and that it was normal for her to have those types of reactions. She'd never been around anyone with cancer. I must admit it hurts when people ignore me or walk out, but I have to look at it from their point of view. They're not stupid, they're just ignorant about cancer. Unless it comes up in their family or happens to them, they don't really check into it because they're afraid of it.

My relationship with my husband hasn't changed at all. He's very supportive and has been like a Rock of Gibraltar for me. I'd sit and cry and cry and he would say, "Everything's going to be fine." I know inside it bothered him, but he's done real well. My husband reads about cancer whenever he sees an article in the newspaper and says, "Well, they're right on the brink of having a cure for it." And I believe they will. The doctors have done a lot of research, so I don't think of myself as sick. I just go on my merry way and do whatever I want to do, so I haven't really let the cancer change my life that much.

I was pregnant at the time that I found out I had leukemia. I was told that it was my choice whether I kept the baby or terminated the pregnancy. It was a difficult decision to make. Nobody would tell me what to do. My husband and I were leaning towards terminating the pregnancy. The doctor that I saw for a second opinion finally came out and told me that if he was in my position he would terminate the pregnancy because the risks were too high. My husband and I were already leaning that way so we decided to terminate the pregnancy. The only doctor who seemed upset with my decision was my high-risk pregnancy doctor, which I could understand.

The people at the apartment complex all knew that I was pregnant. Everybody was asking about the pregnancy, and some people I hadn't seen for quite a long time asked if I had already had the baby. I'd say, "No, I lost it." Sometimes I think it was harder to make the decision to terminate the pregnancy than to tell people, and other times I'd say it was harder to listen to all of the other people and their opinions. One friend told me that her husband said that if it was them, she would have kept the baby. I said, "You can't say that. You can't tell me that if you found out you had leukemia that you would keep the baby. I don't understand how you could make that judgment. You're not in the situation. When it's you, it's a whole lot different." People pass judgment on you something awful and they criticize you for what you do. Then I heard on TV about these pro-life people that take women to court and I started worrying whether or not they would do that to me. After I listen to the judgments for so long, I start getting really angry. When people start throwing their opinions or beliefs at me, then I start telling them off, telling them to mind their own business.

One tenant in the complex asked me how the baby was. I told him that I lost it and he said, "You lost it?" I told him I had to terminate the pregnancy because of the leukemia. He told me I didn't have to do that and I responded that I thought it was the best thing. He said, "For you or for the baby?" And I said, "For everybody concerned." He asked me how I could say what was best for the baby when it didn't have a choice to voice its own opinion. I thought to myself, well even after it was born it wouldn't voice its own opinion. I have been told that there was a live baby inside of me, and I know it was. I've also been told that I killed something living, but I have to look at it another way. When I was at the point where I didn't know how long I was going to live, that helped me make my decision. I thought, "If I go ahead with this pregnancy and that baby is born with deformities or is handicapped—-and the chances are that it's going to be severely handicapped—and if something happened to me, I just couldn't see my husband coping with all that by himself.

When I was in Illinois, I worked with physically handicapped children for three years and I know that a lot of parents don't exactly treat them like their other children. People can be real hard on the parents and I didn't think my husband needed all of that on his shoulders if something happened to me. But if we had a baby under normal conditions and it did have some type of handicap, I could cope with that, but I couldn't cope with the idea that I could have done something about it and it was my fault that the baby was born deformed. I think that was the hardest thing in my life to do because my husband and I had been trying for more than two years to have a baby. I finally got pregnant and then this happens.

Tanya Brundage

*T*he doctor called to tell me I had some "involve-ment" in my bone marrow. He didn't use the word cancer. I don't think they like to tell a patient that they have a cancer just like that. They'll say, "You have lymphoma. We'll treat it like this and that may help." They don't ever say, "You're going to die from it." Not to me anyway, and I'm thankful. But we're all going to die from something, that's my attitude.

I had a hard time saying the word "cancer" at first. I called it lymphoma, which didn't sound like cancer so much. I suppose it's because I grew up with the idea that cancer was the end. I never thought about it much, but I use the word more now, and I don't think the word "cancer" is so strange anymore. There are people who get well from it. I have two friends who had breast cancer who are still well.

I can't remember being frightened when I heard I had lymphoma. I thought, "Well, so I've got lymphoma, I'll get rid of it." I was surprised though, because I never thought I would get anything in the face of cancer. But I'm not frightened about dying. A lot of people die at my age, I'm 64 years old. I've had a wonderful life and I have fine children, grandchildren, and good friends. My life is interesting because I live on a boat and I've been cruising. I can't live forever, that's my attitude. The only thing that saddens me is that I hate leaving my husband alone and I see tears in my grandchildren's eyes every once in awhile. Of course, I guess I'd feel bad if they didn't feel bad. I'd like to see my grandchildren grow up, I'm determined to live.

There was a time when I was depressed about my illness. Now, I've gotten past the stage of "Why me?" We lost a daughter when she was 20 years old. She died in Spain when a big wave swept her off a rocky beach. When that happened, I use to think, "Why me? Why us? Why her?" That was a hard time in my life, harder than this is. When my daughter died, I never said she died for many, many years. I would say, "She's gone away." I never even used "passed away." I don't think she should have died. I was very, very angry and felt like the Lord had taken her away. At the time, I was a very conscientious Catholic. My daughter was so young and vibrant and studied hard and got good grades. I miss her very much, even though she was a twin and we still have her twin sister. But that doesn't make any difference. You can have a dozen children and if you lose one. . . .

My greatest fear is being a burden. My husband has been such a good husband because he takes care of me and he won't let me do things. Sometimes he thinks he ought to let me do things because then I'd get stronger. He does all the cooking and laundry—everything I did, he does now. He also takes care of the boat, which needs quite a bit of care. We've got work to do on this boat that we've been putting off because of my illness. We would like to go cruising and I feel like I'm making life dull for him. I'm not carrying my share of the chores.

I don't want to die, but I realize I may die. You know, we all will die.

Helen Anderson

*C*ystic fibrosis has been a part of my life since I was three years old. I was fairly sick when I was young, mostly with the nutritional part of cystic fibrosis. But I did go through all my schooling with basically no problems and it wasn't something that was talked about a lot around the house. Basically, I was not completely ignorant of what was to come, but I certainly didn't know that it was going to get a lot worse.

I became educated about my disease when I was about 20 years old. The disease had gotten to the point where it could no longer be ignored. I had to start taking respiratory treatments and taking better care of myself in all aspects of my life. The first problem was a major infection and a collapsed lung that happened about the same time. It seems now that it all started at once, but I'm sure that it really wasn't that way.

At one point, I resented my family, especially my parents, for not being more involved in educating me about what was to come with cystic fibrosis. My folks were divorced when I was about six years old. One time when I was about 25 years old, my father came to visit me in the hospital and he said, ''Well, I thought if you outgrew it at childhood, it never came back.'' He thought that I would just have a free life after that. As for my mother, I really don't even talk to her about cystic fibrosis. She gets very emotional and I can't go to her for support because in the conversations I always end up supporting her emotionally.

I had counseling for two years with a psychologist. I went in thinking I would discuss and conquer cystic fibrosis, but that wasn't what we did at all. We talked about resentment, anger, family, finding out why I was having trouble dealing with things. We explored what was at the root of these things. Cystic fibrosis was never going to go away. I was never going to get to the bottom of the disease, so I got rid of some of the other luggage, like the resentment and anger. You have to be ready to see a counselor, it's not automatically the right thing for everybody. Six months before I started seeing my counselor, I would have said, ''Are you kidding? Not me, never.'' All my life I thought I had everything under control. For me, I had to be at the point where I knew things were not going to get better. I was completely stressed out.

I was 19 years old and just out of high school when I got married. My mom had told my husband earlier that I had cystic fibrosis, but there was not much happening with my disease at the time. It was a couple of years before anything even started. My husband is a rock, a solid rock. I probably would not be here if he hadn't been around to help me get through some of the rough times that I've had. The more people I meet who have chronic illnesses, the more I realize just how important my husband is to me. There are so many people out there with such horrendous problems that don't have anybody or have somebody who walks out on them or stays and isn't supportive.

When I get ill, I get frightened that things aren't going to get better. I worry that I won't get through it this time or if I do, I will have lost a lot of ground. I pull into myself. I fear being a burden—that was one of the big things I worked on in therapy. Help is a lot easier to accept now, but it's not completely comfortable. I've always tried to be independent. Each thing that I have help with becomes a little bit of independence gone.

Denise Park

When
you don't feel good, you feel like you're the center of the universe. . . .
When I don't feel good, I feel all alone. It makes me feel very vulnerable.

Thomas Gannon

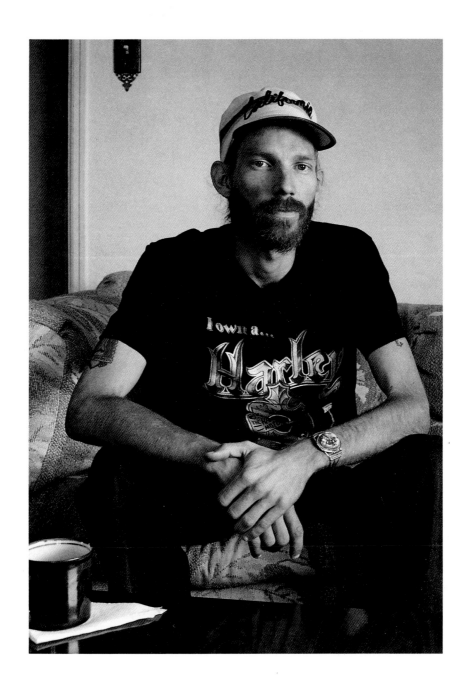

*T*here was a tumor in my sinus cavity and I had to have radiation therapy. I walked around with lines on my face for six weeks. One thing I'll never forget was this lady who really upset me. I was walking from the parking lot of the hospital to the doctor's office. When this lady saw me, she backed away from me and said, "What's wrong with you? Stay away from me!" I just continued walking. I thought, well, if she's that afraid of me. . . .But she followed me and said again, "What is wrong with you?" She stayed a distance away from me and I said, "Well, I have a tumor and I have to have radiation treatments." I was real short. I didn't want to go into the whole thing. She kept following me. I went into the doctor's office and she followed me in there and said, "Look at that lady! Look at her!" This other person said, "What's wrong with her?" And the lady said, "I don't know, but stay away from her!"

When I was diagnosed, they didn't tell me I was going to die. I was told this is the worst type of cancer, but that they took it out. The doctors didn't give me any specific statistics, but my doctor said, "Oh, you'll live to be 80 years old." At that time, I was just concerned about today. I wasn't worried about five years from now. I remarried. I had two children and I got pregnant again. I kept coughing and coughing and feeling bad. I was thinking that this was the worst pregnancy I'd ever had. When I was about 8 months pregnant, my doctor said, "I think you should have a chest x-ray; I think the baby is old enough." So, I had the x-ray and was told it was fine. At the time I really wasn't concerned about what the doctors had to say. They just said don't worry about it. You may have an infection because you have sinus problems. So, I believed that and kept busy being pregnant and attending to the other kids. The doctors knew then that the cancer had spread to my lungs, but they didn't tell me. When my baby was six weeks old that's when the doctors told me that I was going to die in six months. If I would have known that I was going to die, I never would have had two more children and probably never would have remarried.

I think about death. I mean, every day I think about it, but because there are four children, I can't get down in the dumps about it. I have my moments, like at night when I'm in bed, I think about it a lot. My husband gets more depressed than I do. The reason I don't really let it get to me is because if I don't have that much time to live, why should I be sad? If I only have two months, a year, or whatever it is, I want to make the best of it.

Rhonda Gelbman

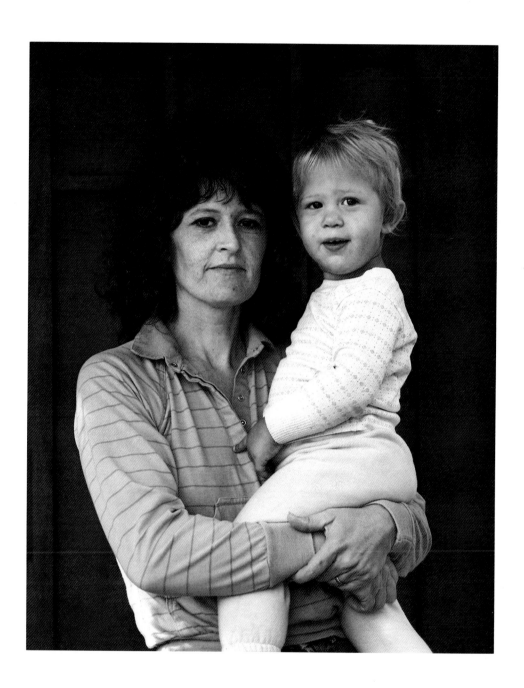

*S*o far, I've had 82 years worth of existence. That can't be destroyed and I want to be careful that the last tip of it comes out as good as the first 82 years did.

I don't want to last long enough to be a burden. I've seen too many people who are too old. There are three categories I relate human beings to. One is they haven't lived long enough; that's when you die too young. The next category is when you have lived long enough; that's when you've lived a good full life and you've accomplished it all. That's beautiful. When you've lived too long, that's no good. In my experience, I've seen too many people who have lived too long. They're just semi-basket cases. I'm getting to the stage where I might be close to having lived too long and I don't like the idea. They shoot horses, I don't know why they can't be as considerate of human beings.

You need to have a sense of humor when dealing with a serious illness. I've been lucky to have a sense of humor. Either you have it or you don't. But if you can have it, then why not. In other words, don't take the whole thing too seriously. There's a line out of a movie that could've come out of Shakespeare. There were four buddies and one of them died. So three of them got a bit crocked and they robbed the casket and set their friend up at the end of the table and had some drinks. One of them started talking to the dead friend, relating to him like he was alive. One of the other guys said, "Come on Harry, knock it off. That's only the thing he walked around in." I think that's a beautiful line. My body is only the thing I walk around in.

Fortunately, I've had what I consider to be a good life and I have more or less accomplished not only what I set out to do, but I did it as well as I could and I've had a good time doing it. I've had some rough times, but even so, I wouldn't want to have been anybody else that I know of.

Leroy Robbins

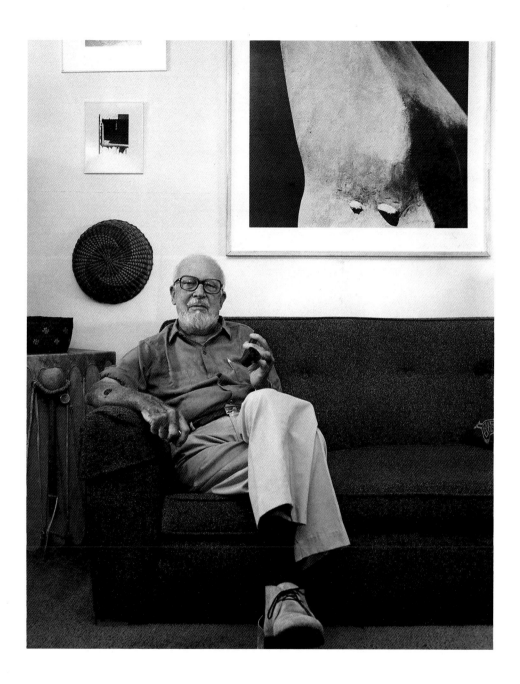

*W*ho's
going to screw in the lightbulb in the garage when I'm gone?

Ross Brown

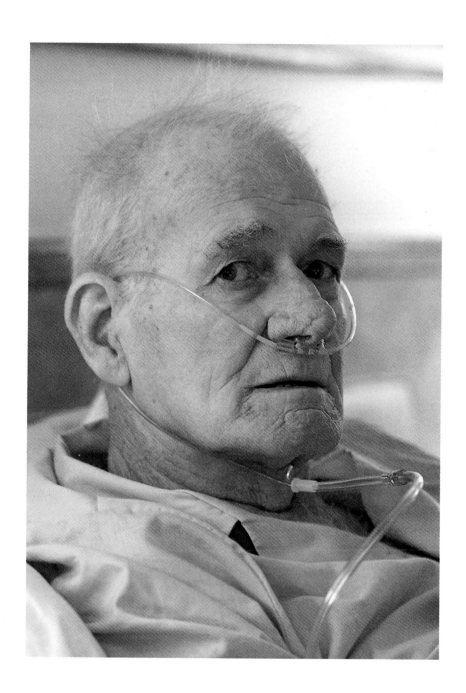

*L*ate 1979 I first found out that something was wrong. I was a little scared but I'd always been very healthy, so I had a high degree of confidence in my body. I wasn't terribly upset when I heard the news. When my illness was finally diagnosed as ALS (amyotrophic lateral sclerosis, also called Lou Gehrig's disease) I was relieved because I knew what it was at last. I felt quite a bit better even though I knew that it was fatal and was going to kill me eventually. I'd come to that conclusion about a month before I got the diagnosis.

I've gone to a lot of different support groups and they've all helped to some extent, providing a way of talking so I don't feel like I'm in solitary confinement. Friendship is a great thing. My relationship with my brother has helped quite a bit by his being there so I wasn't alone and giving me a hug when I needed it. My relationship with my doctor has also helped a great deal because he has been there when I needed him. There wasn't much he could do medically, but he has been someone to lean on.

I lost many friends in the beginning. This is very common with handicapped people. When they first develop a handicap many of their friends become "ex-friends." Possibly, it's because they're afraid to face the handicapped person's new situation, afraid they'll be reminded of their own mortality. Many people do not know how to talk to a person with a handicap. They're afraid they'll say the wrong thing and maybe make the person feel worse, so they don't say anything and they exit. I think I understand how they feel and I can forgive them for it. It wasn't their fault, it was just the way it was. But I've made new friends and I find myself making more new friends all the time. My new friends are quite possibly better friends than the old ones were. There's a deeper understanding and sharing.

Sometimes people who are seriously ill or who have a handicap are discriminated against, but not entirely. How people react to you has some relationship to how you act. If I go into a store with my attendant and sit back apathetically and don't make an effort to be alive and alert, naturally, everyone will talk to my attendant. But if I want to buy something, I sit up and grab the conversational thread and say, "This is what I want." I get their attention. However, something that is very real is the tendency to treat people in wheelchairs like children, but it doesn't have to be that way. It takes a little extra effort on the part of the person in the chair to sit up and participate a little more than it would for an able bodied person. If I interact with people as an adult, not as a child, and carry on a conversation with them, a great many will respond to me as an adult. But if I sit back and expect to be treated like a child, I will be.

Right now I don't think of myself as sick. I don't feel bad. If I have a bad cold or the flu or when I develop pneumonia, then I'm sick. But I feel fine physically. My mind is okay. I get up and go places, I do things. Granted, my body won't do anything I tell it to do—I cannot move my body below the neck—-but that's not an illness, that's a great inconvenience. The ALS will undoubtedly make me ill as a side effect in the future, and it will kill me eventually, but then I'll be sick. Right now I'm not.

Lois Maiwald

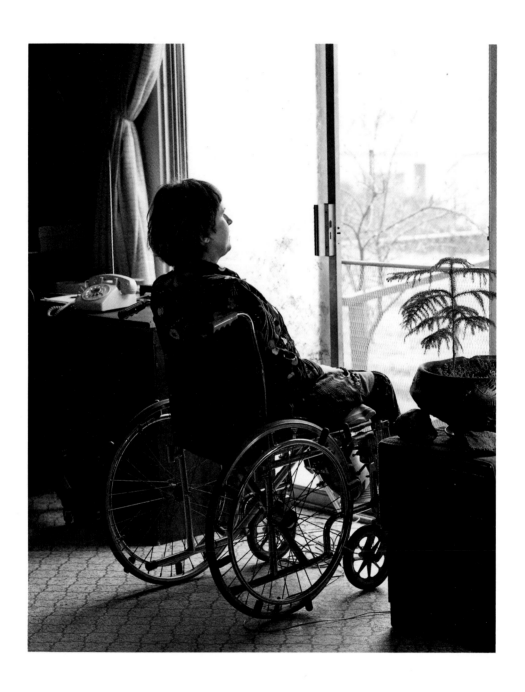

*M*y gynecologist told me, "You're all right, you've got a spastic stomach, you're just nervous. Take these pills and everything will be all right." Well, within two weeks my stomach cramps got real bad and I threw up. I went to see my doctor again and she admitted me to the hospital for testing. Immediately I saw a gastroenterologist. I said, "I don't have cancer of the colon, do I?" He said, "No, you're much too young for that. Don't prove me wrong." When I think back on it, it's almost like I knew intuitively that something major was wrong. There were numerous tests and five days later I had a surgeon, a gastroenterologist, a hematologist, an oncologist and my gynecologist. They decided I needed surgery because it was a tumor.

What really bothered me was that I had five different doctors, but none of them was able to tell me or say to me, "You have cancer." The person who actually came right out and told me was a surgeon who came in as "a friend of the family" to offer me a second opinion. I found it interesting that this doctor, being an outsider, was able to just say, "This is what you have," whereas the other doctors, who were taking care of me, couldn't tell me. I don't know if they were afraid of how I was going to emotionally react, or if they were just having a hard time believing that I had the cancer in my colon and I was only 39 years old. I had them stumped for five days of tests in the hospital; they were really boggled for awhile and I don't know if that had to do with their own emotions. I could have used a therapist at that point in time. My doctors just avoided the word "cancer," which seems to be real common in our society. I was the one who had to say to the doctors, "Oh, you mean I have cancer and this is where it is, and describe it to me, and I want to see the x-rays and so on."

When I heard I had cancer, it wasn't that much of a shock. I think I almost intuitively knew that something was seriously wrong. I didn't mind being matter-of-fact about the cancer. I figured it was something that had to be taken care of, so let's do it. But people started treating me a little bit like a piece of porcelain, which really pissed me off because people are so afraid of the word, the disease, everything.

My mother fell apart when she heard the news, she just kept crying. I know my mother has a real problem dealing with the possibility of death. My father fell apart emotionally, too. My parents had a tough time seeing me in the hospital, not having control, with bandages and tubes hooked up to me. That is one time in my life when I felt I needed a support system and I needed it from my family, but it wasn't there, except for my sister who was a great support. When I saw the surgeon, I remember breaking down emotionally. I just started crying and the doctor asked, "How are you holding up?" I said, "God, I'm like the tower of strength for my family, and I wonder why they can't be there for me." The doctor gave me the name of a couple of psychiatrists, but I ended up not seeing them because, at that point, I was really "doctored out."

While at the same time being matter-of-fact about my illness, I also felt like I was going to explode emotionally. Trying to comprehend and understand what was happening to me and being very angry at the doctors and my family. Sometimes I just wanted to scream. There were so many questions at that time and I was bothered by little things like, "Vera is very delicate, she can't lift ten pounds because of her surgery." Or my mother saying dumb things like, "Don't put toast in the toaster because you can get cancer from the toaster." I felt like I was

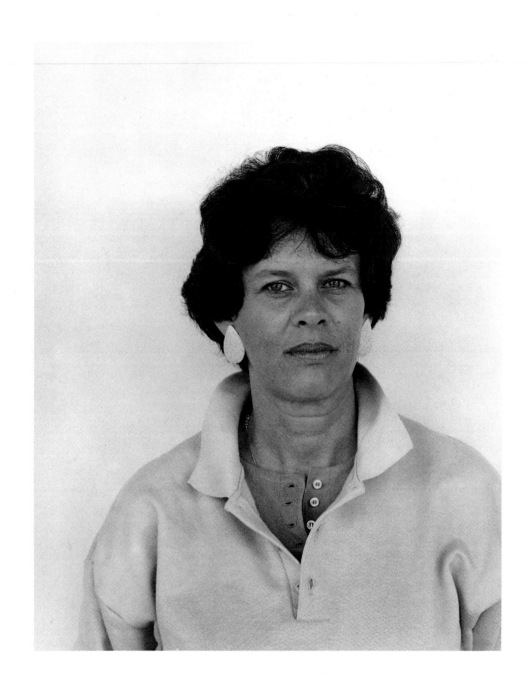

being excluded from normal, everyday kinds of activities and that made me angry because it almost takes your dignity away. I had a couple of giant, explosive arguments in the household where I am living. Obviously, I have to work out more of the anger and I know it's not an overnight thing. I think a lot of the anger is, "Why me," which I think is very natural. It just seemed easier to be angry at somebody else, it didn't matter who it was.

After I had been recuperating for about three weeks, I was introduced to a woman who also has cancer. She's really a wonderful woman. She invited me to a "Make Today Count" support group, which ended up being very difficult for me. There were about 30 people, older people who had a lot of cancer of the kidney, cancer of the lung; you name it, it was there. We went in a smaller group and said, "Hi, my name is such and such. . .," then told about our illness. I was very uncomfortable because my disease and the whole experience were very new to me, and I was with this big group of people I didn't even know. For me, my illness is such a personal thing. The first night after I went to the group I thought it was pretty neat, I was able to talk about my illness. Then, two days later, I remember sitting on the beach near the ocean and I started to cry. The impact of what had happened finally took its toll. So that turned what I thought would be a positive experience into one I was very uncomfortable with.

If I go to dinner with a girlfriend, for example, I find that we talk about lots of other things. But when it comes to bringing up my having a doctor's appointment and I want to discuss my illness, she'll change the subject. Or she'll say, "Oh, you're going to be all right. You'll be fine." People are really afraid to discuss cancer. I've been at dinner with friends and someone brings up something that might have happened in the news related to cancer research, and suddenly there's a heaviness in the air that descends and people are afraid to keep talking about it because they're afraid of how I'm going to react. It bothers me that all of society has such a problem with cancer and it bothers me that my doctors had trouble saying "cancer" because that's where so much of a patient's fear comes from.

When I first got out of the hospital and was home recuperating, I needed to talk about it. People would say, "I understand you had surgery. How are you? What happened?" I would whip out my stomach and show them my scar because I was real proud of it, and because I needed to talk about it. People couldn't believe I was talking about the cancer in a very normal way. Maybe that was my way of working out the whole thing. I felt like people did not know how to respond to me emotionally. I would tell them I had a 60 percent chance of getting the cancer again and a 40 percent chance of not getting it. They would hear the statistics and wonder what they could say to someone who could possibly die. That's what a lot of it comes down to. . . the whole death issue.

I have thought about death and I often wonder if my calmness through the whole surgery process and being in the hospital was connected to that thought. But if I think about death now, when I'm feeling good, I start to flip out a little bit. But at the time when I was so sick and hadn't been feeling well for a long time, and finally understood why I had a stomach ache and felt like crap for so long, I felt calm knowing I might die. I wonder what the calmness has to do with the whole death issue. Death is an issue I'm trying to work out at this point in time. I have days when I'm very comfortable with it, when I feel like I'm doing what I really like to do as far as the arts and working. At times like that, I feel I've done lots of things and it's okay if my life is

going to end. I've started to do a lot more research and reading on the spiritual aspect of death, the metaphysical approach. On the days when I'm uncomfortable with death, it bothers me. I wonder if I want to be buried or cremated. It's more comforting for me to believe in reincarnation, thinking, "Okay, if I die, I'll come back...."

If I knew I could do my life over again, I would not let myself get so stressed out and not let things bother me. There are responsibilities I could have done without, which were somewhat handed to me or that I took upon myself in terms of my family. I think that comes from being the oldest child and a number of things that happened when I was little. I don't know what else I would change. I have done things in my life that I'm really glad I experienced that I would never change.

I did finally go to see a clinical psychologist, one who has cancer of the lymph nodes. He shared something interesting with me that he had discovered when he was younger and first found out he had cancer. He's now in his 40s. He told me, "When I discovered that I had cancer, I did tons of research and even went to clinics in Mexico. I felt like I needed to know everything; every possible opinion from experts and all the details of my disease. I came to the conclusion that I could do all this research, but I would rather have fun in life—to basically enjoy every day and stop and smell the roses." He added, "Find yourself a good oncologist that you can work with medically, and find yourself a therapist you can work with on emotional issues, and then enjoy life." So, I stop and smell the roses a lot more now. I realized, "Holy shit, I've got a second chance!" And the little things that I see people bitching about, which I used to bitch about too, they don't really matter all that much anymore. I just live each day a little more fully.

Vera Humburg

*W*hen I went to the doctor, it felt like he was only concerned with the physical part of the treatment of my cancer, and there was no concern about how I felt emotionally. It was strictly a physical treatment and I think a doctor has to look at the whole picture; the emotional is as important as the physical. When I told the doctor I was depressed, he gave me a pill—I don't think that's the way to go. There needs to be somebody working closely with the oncologist to offer an emotional approach to the disease, along with the physical treatment.

I am an independent person and this illness has hit me below the belt. I have to depend on other people, which is one of the hardest things for me to accept. When I can't do something myself and I have to call on other people, that's when I become particularly frustrated. I guess I was raised with a strong sense of independence. My mother has always been avant-garde with the attitude, "Hey, take care of yourself." She thinks women's lib is terrible, but when you look at her lifestyle she's always been very independent. I was raised that way. There are days when I get so down because I feel I can't handle things myself and I feel like my medications aren't working. At times like that I ask myself, "What's the next step?" rather than saying, "Okay, I'm getting better."

After learning that I had cancer, my major concern was fear of the unknown. It's easier for me to talk about the disease now; it's not nearly as bad as it was at the onset. Acceptance and being able to talk about my illness helps to get rid of fear, but I'm definitely a worrier. I worry about things before they even happen; I've always been that way. The thought has occurred to me, "I've got a terminal illness," but everybody out there walking down the street is going to be terminal. I'm just not ready, that's all. I'm still fighting.

Judith Henry

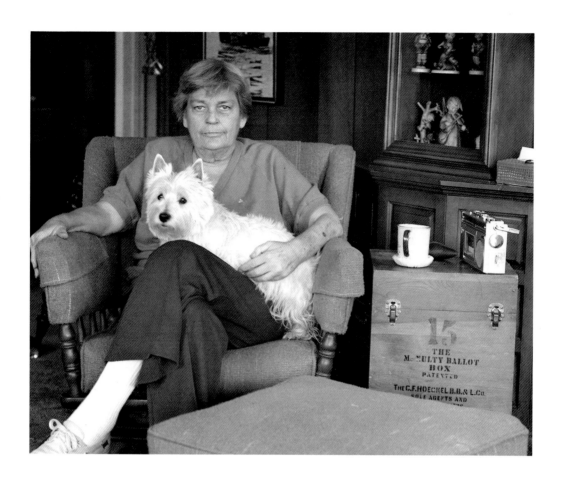

*M*y wife asks how I am doing, but she doesn't want to get into how she is doing. She avoids the fact that she is wearing herself down caring for me and that she isn't getting much attention. For awhile, I felt rotten all the time and I wasn't a terrific guy to be around. . . She doesn't want to open up and share her own feelings.

David Goodbody

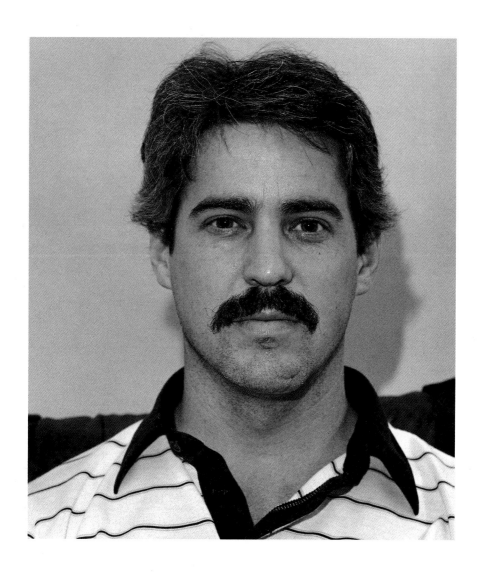

*F*or about a year, I was complaining about pain in my left rib cage near the scapula, but the doctor couldn't find anything. I work in obstetrics and gynecology as a nurse practitioner, but it never dawned on me that I'd never had a mammogram. The doctor suggested that I have a mammogram and I said, "No, who has time?" After about six months, the doctor told me he was ordering a mammogram. By the time I got home from having the test, the doctor was on the phone saying that there was something suspicious and it could be cancer.

Once I found out I had an invasive cancer, my first thought was of my son who was 16 at the time. I am a widow and I thought, "What's going to happen to my child?" He's 18 years old now, but it still stays in the back of my mind, "What's going to happen to my child." It's up to me to make provisions, but I figure I've gone this long, maybe God will give me the chance to be here when he's 21 and he's absolutely legal. I think if it wasn't for my son, I would just crawl in bed and put the covers over my head sometimes. But I think even though I resent feelings and resent being in this position, it's good for me because it makes me go when I don't want to go.

I am independent and have always been the one that everybody leaned on. It's been kind of hard for my family to restructure their relationship with me. One thing that was really hard is that my mother was sick at the time I was diagnosed and she has since passed away. I'm the oldest and I have a sister who's two years younger, so she had to take over my mother's care, overseeing things that I usually do. That was a change. My sister is caring and worried for me, but as long as she sees me upright she feels that things are okay. But she doesn't know that it sometimes takes hours to get in that position.

The people I thought would be supportive weren't as supportive. One in particular, who's a nurse practitioner, had breast cancer years ago. She shied away from me and then called me one evening, just falling apart. She said she couldn't cope with it. That threw me off because I thought she, of all people, would understand. She talked to one of the doctors about it and said that she couldn't handle it. And I said, "Well, she doesn't have to handle anything, I'm the one who has to handle it." But then, I have another friend who had a double mastectomy and she's taken me for my appointments when I was really weak. I also found other people who I thought would run the other way because they would be afraid, being very supportive.

I'm religious and I have a lot of faith, that's what keeps me going daily because sometimes I'm up and sometimes I'm down. I also believe that the doctors will do the best they can. That's all you can ask. They're not God.

Letitia Bembry

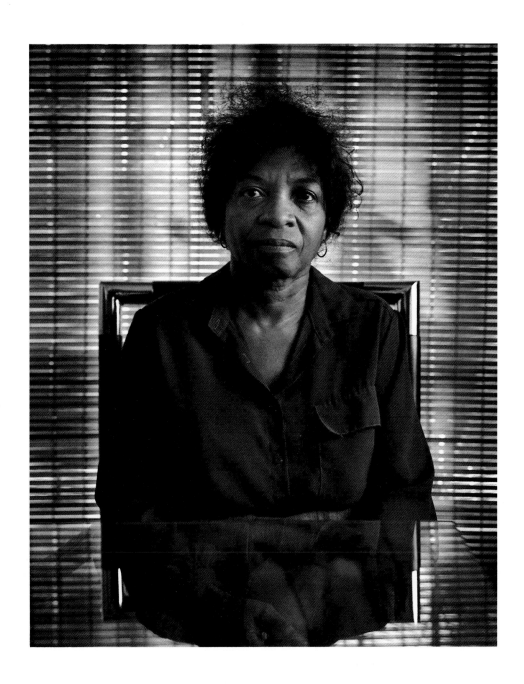

*T*he first time I was diagnosed with cancer was in 1974. Now, I've had cancer three times. It doesn't bother me anymore to think about dying, but it did at first. The first time it was a shock. I even quit smoking cigarettes. When the doctor told me I had cancer, we sold everything we had, except for this house, and bought a motorhome and took off for two years.

I keep hoping my wife will live longer than I do because I don't know what the hell I'll do. I keep telling her she has to live longer. If she dies, there's nobody to take care of me. I couldn't do it myself, that's the big fear. Sure, the kids will take care of me and hire someone to come in, but it's never going to be like it is with the two of us. I might be fussy, but there's nobody who can cook the way my wife cooks for me. We know what each of us likes.

Don't let no strings hang, that's for sure. Have everything buttoned up so it don't hang on someone else. Uncle Sam comes and takes everything anyway. Just live from day to day, that's all. If I want to eat pork chops, we'll eat pork chops. If I want to eat bacon, we'll eat bacon. If we want steaks, we'll eat steaks. We don't fuss around with margarine and all this other crap to save cholesterol and all that. We get butter and we have our grease. Enjoy the years you got left.

Edward Hopster

*F*inding out that I have cancer has been very emotional for me, especially since my husband heard he has cancer again. It hit both of us. I mean, he's down and I'm down and neither one of us can take care of the other. I still try to do as much as I can for my husband, but I can't do the things I would really like to do all the time. I try to help him get into the wheelchair, but my daughter had to help us last week and now my sister and her husband are staying with us.

When they told me I had cancer, I knew it wouldn't be long for me. The doctor says there's always a chance, but there are going to be side effects. I think of a lot of things, but right now I just can't think. The news was very hard to take, but on the other hand, I thought, "Well, I guess I've had a good life and that's what God's got planned for me. I don't want to change it."

Adelina Hopster

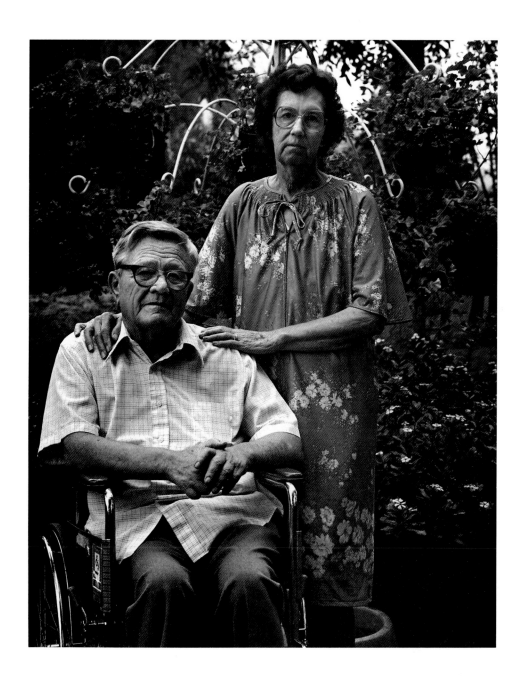

*I*t's the frustration. I want to do something and I haven't got the strength. If I could get back on my feet and feel like I could stay there for awhile, I'd feel a lot better about this. . . . I don't fear death, I fear getting there. Make my death quick.

Carole Writer

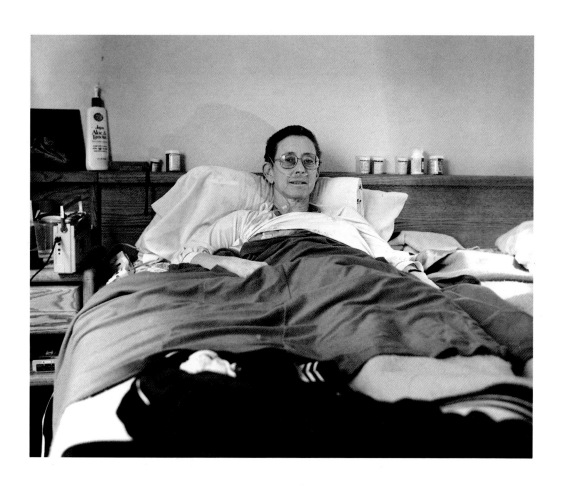

*A*lmost two years ago, I suspected that I was ill, but the doctors told me I was fine and to stop wasting my time. A week ago I found out that I have AIDS. After this year, I'll probably get sicker. Right now my attitude is good and I can't see any change in my life, except that I'm going on disability.

I've thought, "Why me, why now?" In my career I've made a lot of gains. I came from a middle class family and my father made about $40,000 a year, but he had 10 kids. So my parents really couldn't give me much and they were always saying, "If you want it, you have to work for it. There are no silver platters out there for you." So, I've been working since I was 12 years old doing odd jobs, and I moved out when I was 17 years old. I've had a pretty hard life and I didn't have a skill, but I wanted to get into banking. Now, I'm a finance operation supervisor at a bank. The company I work for is extremely supportive, although some people at work have refused to work with me because I have AIDS. One woman said, "I'm quitting if I have to work with him if he has AIDS or something contagious." They gave her a raise and she stayed. That's what she was trying to do.

I don't think I'll ever be a burden to anyone because I never have been. I'm sort of an independent individual. I just go on. There have been a lot of doors slammed in my face and it doesn't affect me. I just tell myself to knock on the next door.

Well, now I am thinking about taking care of the body after I die because I don't know what to do with it. If there are no instructions or money, they'll probably just hand the body over to my parents on a white slab. I decided to have my body cremated and to take care of all the arrangements myself, even the invitations. Do you send out invitations to a funeral? There won't be many, maybe I shouldn't send out invitations. I hate to be gone and nobody knows who I am.

I don't fear death but I fear the pain of dying. If the doctors sedate me, fine. But all the pain I might go through—I think there's a lot of pain—when your lungs stop moving and your heart stops. I have thought of suicide but I want to die of natural causes for the insurance and my parents. Suicide would make me lose everything. Anyways, I couldn't do it myself, I couldn't take the pills knowing that I'm not going to wake up. I'll wait, the doctors said it could be two years or it could be longer.

Arthur Cooper

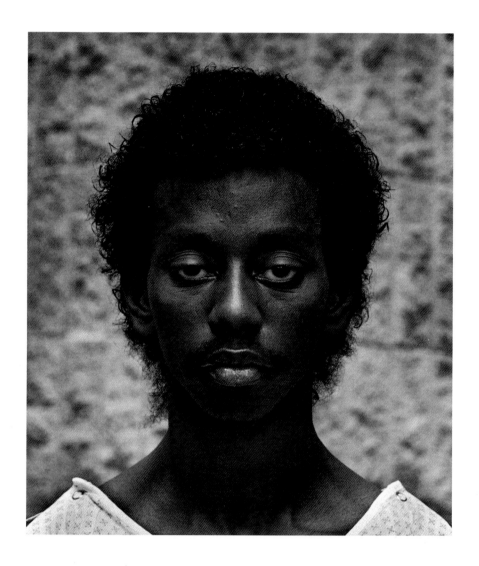

A person who is sick wants to be a part of life and the things that are going on around him. I want to participate as much as I can, don't leave me alone. I want the people I know to spend time with me and enjoy my company while they can. . . . For God's sake, please don't treat me like an invalid.

The hardest thing for me is being paralyzed. With ALS (amyotrophic lateral sclerosis), you lose the ability to control your muscles and the more I move I die. My hands are going now, it's just a slow process. I'm more scared of being trapped and unable to communicate or do anything. I'm going to die eventually of respiratory failure; either I'll get pneumonia or I'll probably get shut off the respirator. Right now, that's the farthest thing from my mind. Now it's everyday living, enjoying what I can, while I can, and doing as much as I can.

In general, I think I'm handling it pretty well. I sort of roll with the punches and do what I can. If I can't do it, I get somebody else to. One of the hardest things to do is keep my mind occupied. I watch TV and I read a lot, but I miss the interaction with the people and the problem solving I did as a computer programmer for the past 22 years. I see a psychologist once a week, which has been very helpful. This illness has forced me to get my act together. I also inherited some money that allowed me to buy a place to live and I don't have to worry about money. What I miss most are backpacking and chasing women. If there was one thing I could do over in my life, I would have started backpacking earlier.

Right after I had the diagnosis and the operation, I took a trip and visited all my relatives. They are very supportive and come to see me about once a month, flying across the country. I seem to have more close friends now than I had before, but my closest friends are people I wasn't close to before.

Even though I talk funny and don't walk and have no control of my hands, the only thing affected is my output. My input is fine, my brain is fine, I'm just basically trapped in this body. So, anything the doctors can do to make life easier for me physically I appreciate, but I don't want any sympathy.

Fred Clark

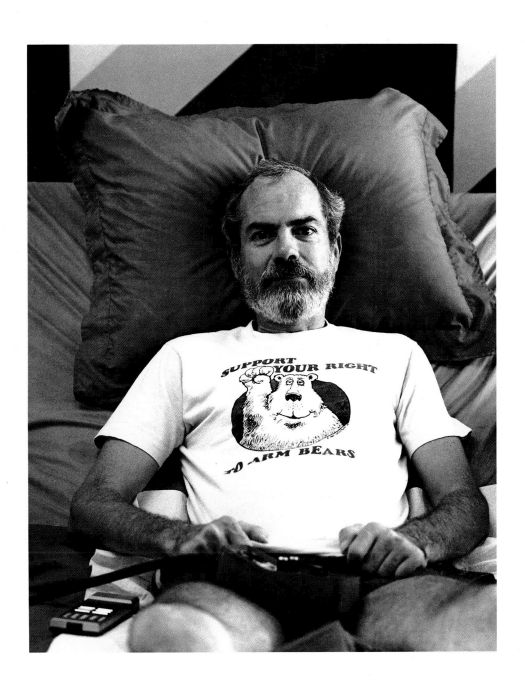

*W*ho wants to hear an old lady moaning and groaning? I don't want to be a burden to anyone and that's what keeps me going. I'm just not going to give up. It's a great fear and I try not to dwell on it because I think the answer is to take each day as it comes. If things happen, they happen. That's the answer.

Mildred Gaulin

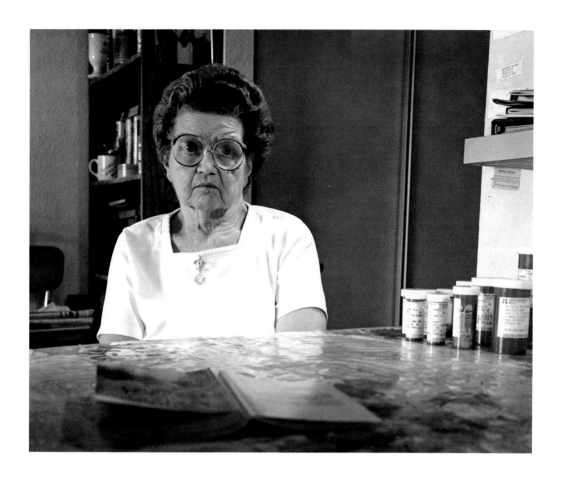

*D*octors have a way of putting your illness in technical terms when they don't have good news. I don't mind because it gives me a little bit of a chance to digest what they've said. They told me I had a malignant growth and I said, "Oh, okay," but then I thought about it and I realized I didn't know what all of that meant. Then I asked again, and they told me a little bit more. The more my curiosity grew, the more questions I had. I don't think most people can take that kind of news all at once.

It took a couple of days for the news to sink in that I had cancer. The first couple of times I heard it, the reality didn't register. Then all of a sudden one night, I got kind of depressed. I have two kids, a four-year-old and a one-year-old, and I was feeling pity for myself that I possibly wouldn't see them graduate from high school and know what they'll be like. That's the hardest part for me.

This disease has changed my life and I have changed my life. As soon as I got out of the hospital, I went out and bought a sailboat, which I've been putting off for five years. I decided it was now or never. Now, we go sailing almost every weekend. I have also become more appreciative of the time. At work, people are more concerned with my health than they were before. In the past, they couldn't have cared less what I ate for lunch, and now they ask, "Have you eaten enough? " and they try to push food on me.

When friends originally found out I had cancer, they were very concerned. But I'm not a sickly looking person, that's the hardest part about this whole affair. If I looked frail, I would get a different reaction from people. I look the same and friends kind of expect me to look wasted away. It's very uncertain. There are days that go by and I don't think about it. Part of that might be because the cancer doesn't appear to affect me physically. Even now, I have to pinch myself and ask, "Is it really real?" Other than having the scar on my stomach and going for chemotherapy once every six weeks, that's the only real evidence of having any kind of sickness. Sometimes I feel guilty that I don't have the pain and look sick. I wonder, "Why am I having far less pain than other cancer patients?" and at the same time I ask, "Why me? Why do I have cancer?"

As far as I'm concerned, death happens to all of us. I don't dwell on it. I don't think any of us would dwell on it or we wouldn't be able to make it through our lives. I don't think any of us look forward to death.

Dennis Reddish

When I found a lump in my breast and went to the doctor, he didn't think it was cancer at first. He watched it for two weeks and it was still there, so I had a biopsy done. I was awake during the biopsy, so I asked, "What do you think, does it look like cancer?" The doctor said, "No." I was just sure I had cancer before I went in for the biopsy, but I thought that the surgeon does enough surgery so he knows if it looks like cancer. After his comment, I was ready to celebrate. All my preparation for the worst went out the window and I celebrated. One day while I was at work I got a call from my doctor. Right in the middle of work he said, "Mrs. Sword, I have bad news for you, it is cancer." That just about blew my mind.

My husband doesn't want to discuss my illness any more than I do, and maybe less. If I try to talk about making plans, he just ignores me. I think my husband believes it's good for me not to talk about it; that's what I'm afraid of. He knows that I get all weepy, so he thinks if we don't talk about it, I won't feel as bad. I can talk to my younger daughter easier than I can talk to my husband. My older daughter, as long as I feel good, she's happy and supportive, but she's not supportive when I don't feel good. It feels like all of her anger about my illness comes out, so I almost hate to feel bad.

When the tumor spread to my brain and I had the seizures, my husband took the whole week off and stayed with me. He was supportive, but he sat on the couch and watched TV the whole time and we never talked about anything. When I got the brain tumor, it was one of the scariest things. I don't want it to happen again. I wish they would put me to sleep if that were to happen again. I'm not afraid to die, but I'm afraid of getting there. I just don't want to be sick or be a burden.

Sara Sword

*N*ow, more than before, I'm getting used to the idea that what is going to be is going to be, so I am not so fearful of dying. Sometimes I think, "Well, all of us have to die sometime. It could have been that I died in a traffic accident, so maybe having cancer is one way of preparing myself with God and with my family. In other words, my family is getting closer and doing things that I would have taken for granted before because my life was so busy. At the time that I first found out I had breast cancer, I was working so I didn't have as much time with my children as I wanted to. Now I think, "This is the time to slow down and enjoy life."

My relationship with my husband has improved, we have gotten closer. I noticed that he is helping, especially after this last time when I had a tumor in the liver. I've told him, "I'm happy that I have you, you've been like a pillar to me." I hardly got up out of bed those first few days when I was taking chemotherapy, so my husband would bring me food and help me with a lot of things. My children also seem to express their feelings a little bit more. I guess they realize that they don't know how long I have, so now they tell me their feelings and beautiful thoughts, like "even though I see the pain in your eyes, I know you're trying to do the best you can." They also tell me how much they admire me and really appreciate what I have taught them. I imagine if I hadn't gotten ill, they wouldn't have told me these things until they were older.

I still have hopes of getting cured or at least going through remission and living a few more years to see my children married. None of them are married and I don't lose that hope. Two of my children live at home, a 20-year-old girl and a 14-year-old boy. The fear of dying is not so much what's going to happen to me, but it's the fear of leaving something I'm already used to. I also think about my children that are still at home and that they're not married. If I were older and my children were already married and had families, or even if I knew they were leading separate, fulfilled lives, I don't think I would fear the thought of death so much. I still feel that I haven't fulfilled my mission as a mother. I was late in forming a family because I had trouble having children, so that's why I think, "God had a purpose and that's the part of fate that I had. Maybe I will get better because maybe my mission isn't complete."

Virginia Gomez

*T*en years ago, when I was 30, I first found out I was ill. The doctors had a hard time diagnosing what was wrong with me. I remember my doctor telling me at the time I was going to surgery to confirm the diagnosis, that he thought it was a lymphoma. That meant nothing to me. After the surgery, he told me I had lymphoma and I asked him if it was malignant. He said yes.

Right from the start I felt that this disease was changing my life. After the doctor explained the disease to my husband and me, we had a pretty good grasp of what it was. When I went home from the hospital that same day, in my mind I wasn't sick anymore. I had to be well because sick people are in the hospital and well people go home from the hospital. Our bedroom is upstairs and I weighed 88 pounds, dripping wet, and was very weak and couldn't maneuver the stairs. We had a hospital bed brought in and put in our library. As I lay in bed, where I spent most of my time, I had a lot of trouble reconciling this disease with myself. I kept talking in terms of, "Well, I have this thing. . . ." In the hospital I could say "cancer," but once I was home I couldn't say it anymore.

After being home for about four days, I was writing to a friend in Texas who had lost her mother about six months before to cancer. She and I are very close and I had to tell her what was wrong with me. I was writing this letter about two o'clock in the morning and when I got to the word "cancer" I just stopped because I didn't know what to write. I rang my little bell and woke my husband up. He came downstairs and I said to him, "What do I tell Jan? What do I say?" He said, "Tell her you have cancer." My response was, "But I can't tell her that, she'll be too upset, and besides that, I just can't say the word." So we talked together, we cried, and finally he had me say the word "cancer" out loud. Once I heard it, the word didn't seem so bad anymore and from that point on, I could say "cancer."

Another friend came to visit me from out-of-state and could only stay in the room for about two minutes. She left the house just as quickly as she could, almost ungracefully, because she was terrified she would catch the cancer from me. That was devastating because we have a very close relationship. We had known each other since we were small children and it was two years after that visit before she made any attempt to reconnect the friendship, and only because she went through a similar scare. She learned it wasn't a contagious disease. Two years out of a relationship is an awful long time, but because we had such a solid base, we were able to put it back together.

In the last 10 years it seems like the public has become a lot more aware of cancer. I don't find the ostracism now that I found 10 years ago. Cancer patients are coming out of the closet. They're not afraid anymore to talk about their cancers and there's so much more information available now. As a cancer patient, I need to be able to talk about it. I need to talk to my friends and tell them what I need. However, I find it very hard to ask people to do things for me. I might say to my daughter, "Would you get me a glass of water, " but I couldn't ask a neighbor to make a casserole for me. I feel the biggest thing someone faces as a cancer patient is educating your friends and family to let them know what things you want. My aunt had cancer and her husband could not discuss it with her. Now that my aunt has died, my uncle has problems because he realizes there were times she wanted to talk to him about it. He could not accept

the fact that she was dying. Now, he regretfully says, "I should have talked to her about where she kept the favorite recipes, where she put her wedding ring, how she wanted some of the household things distributed." So, each cancer patient has to work out individual needs, we are all unique.

One of the biggest problems I had with my family and friends was right in the beginning when the doctor told me I had cancer. He said, "You are a very healthy person who happens to have cancer." At first I laughed because it seemed like a ridiculous statement to make, but I have hung on to that statement and have always tried to be healthy. This is my third time out of remission and I've tried each time to keep the normalcy in my life, to keep working in a job as well as being active in different organizations. However, my family tends to treat me very fragilely when I'm out of remission; we have a dialogue going on all the time about this issue. It's a tough balance to find because I have to still live as a normal person. I will not accept that the disease is stronger than I am, but rather I am stronger than the disease and I control it. It may have taken me over for a little bit, but I know from educating myself about the disease that it is controllable, so I can't get to the point where the disease overtakes me.

One of the ways that cancer has changed my relationship with my family is that it's made us a lot more aware of the things we hold dear in our lives. I don't think that we were real materialistic before, but we are much less now than we were. I realize that the relationships between people are a lot more important, we certainly have grown a lot closer together. I have a fantastic family, not only my husband and my daughter, but my extended family and our friends. On the days that I indulge in self-pity, and I think that we all do, different friends say to me, "Oh Sherry, you're so strong. You're amazing, it just boggles my mind." I get my strength from that; it takes me out of feeling sorry for myself real fast.

My daughter was eight years old when I was first diagnosed and my husband and I decided from the very beginning to be honest with her about my illness. She has been real good, although on chemotherapy days she can hear me being sick and asks to go to a friend's house. We know why and that is not a problem. My daughter asked if I was going to die and we told her no, we didn't believe so, but she would ask other friends that same question because she had to know that everybody felt that way.

We are not regular "go to church every Sunday people," but I have a strong belief in God and that there is something out there that helps me and protects me. That's part of where I get my positive feelings. Another thing that helps me tremendously is that some of the funniest things in my life have happened when people found out I've had cancer. One world classic, funny story was when I had to get my driver's license renewed. There is a law in California that states when your picture is taken for your driver's license, you cannot have your head covered. The second time I went through chemotherapy, I didn't wear a wig, only caps. I called down to the Department of Motor Vehicles (DMV) and talked to a Mr. Jones and explained my situation . He said, "That's no problem, when you get to the window to have your picture taken, tell the clerk to call me and I will come down. There's a form that can be filled out." I asked, "Are you sure that I'm not going to get any hassles?" to which he responded, "No hassle whatsoever."

I went down to the DMV very confidently, took my test, got up to the window and this clerk looked at me and my hat and I could read his eyes, so I just told him to call Mr. Jones. The clerk said, "It's against vehicular code 43962.8 to have your head covered in your picture. You have to take the cap off." I said, "Just call Mr. Jones, I don't have any hair." He looked at me and said, "Lady, you don't have any hair? Do you have a brain tumor?" I answered, "No I don't have a brain tumor, I have one in my stomach. Just call Mr. Jones." I guess I had a few wisps of hair showing and the clerk said, "But I see hair." I said, "Yeah, but that's it. Just call Mr. Jones." The clerk persisted, "I don't understand lady, if you have a tumor in your stomach, how come you don't have any hair on your head?" Then I explained, "I'm taking chemotherapy and it makes my hair fall out. Just call Mr. Jones, he said you weren't going to hassle me." Then the clerk turned the application over and noted one of the items that I signed that stated I would not perjure myself and that I had signed a statement saying I wasn't taking drugs that make it unsafe for me to drive. He said, "Lady, you lied, you signed this." I said, "No, I didn't lie. The drugs don't make me unsafe to drive, they just make my hair fall out, and besides that, when I have a treatment, my husband drives me. Just call Mr. Jones."

There were people behind me and I was ready just to whip my cap off at that point, but not quite brave enough. Finally, he looked me straight in the eye and said, "But lady, you can't drive, you're bald." I thought, "This is it." Then I said, "There are all kinds of bald-headed men who can drive a car, give me three reasons why a bald-headed woman can't drive." He opened the drawer, took the form out, filled it out, and said, "Step in back of the yellow line." Then he took my picture.

Sherri Marsh

About the Author

Eric Blau has been practicing internal medicine for the past 12 years and is an assistant clinical professor of community medicine at the University of California School of Medicine, San Diego. As the son of a professional photographer, Blau has been taking photographs since he was a child. His work has been exhibited in museums and galleries nationwide. Blau is also a recent recipient of a Polaroid Corporation Artists Support Grant and a Public Arts Advisory Board Grant. He resides in La Jolla, California, with his wife Julie Gollin, who is also a physician.